Chiara Frugoni

PIETRO AND AMBROGIO
LORENZETTI

Scala Books

distributed by Harper & Row, Publishers

CONTENTS

© Copyright 1988 by Scala, Istituto Fotografico Editoriale,
Antella (Florence)
Layout: Fried Rosenstock
Editing: Karin Stephan
Translation: Lisa Pelletti
Photographs: Scala (A. Corsini, M. Falsini, M. Sarri),
except no. 17 (Giraudon, Paris)
Produced by Scala
Printed in Italy by Conti Tipocolor, Calenzano (Florence)
1988

Pietro Lorenzetti: Biographical Notes

Vasari was the first to write a biography of Pietro Lorenzetti: an unfortunate beginning, for he misunderstood the artist's name. This mistake was repeated for centuries and, as a result, critics did not know that he was Ambrogio's brother and were not able to analyze the stylistic similarities and the mutual influences, the obvious consequences of a professional collaboration which was in fact much closer than the documents and the inscriptions on surviving paintings suggest. In any case, Vasari thought his name was Pietro Laurati, because that was the signature he thought he read on a painting done for the church of San Francesco in Pistoia, now at the Uffizi, showing, as he described it, "Our Lady with a few Angels very well arranged around her." But his interpretation of the signature, *Petrus Laurati de Senis*, was both incomplete and incorrect, for it reads: *Petrus Laurentii de Senis me pinxit anno Domini MCCCXL*. Despite the praise Vasari bestowed on Pietro, he must have had a fairly limited knowledge of the works and style of the artist, for it would have been enough for him to have observed with more attention those frescoes that he indicated as revealing Pietro's special talent: "Throughout his life, he was loved and called all over Tuscany, for he had first become known from the stories he frescoed in the Sienese Spedale della Scala; in which he imitated in a way Giotto's manner as it was known throughout Tuscany, so that it was believed that he would become, as indeed happened, a greater master than Cimabue and Giotto and all the other earlier artists; because the figures of the Virgin climbing up the steps of the temple, accompanied by Joachim and Anne and greeted by the priest, and then the Wedding, are so beautifully ornamented and so simply wrapped in the folds of their clothes, that the heads give an impression of majesty and the arrangement of the figures shows great talent."

Had Vasari been less careless he would have read the inscription on these frescoes, which was first mentioned by Ugurgieri in *Pompe senesi* (1649): *hoc opus fecit Petrus Laurentii et Ambrosius eius frater, MCCCXXXV*. These frescoes, which must indeed have been quite splendid, were destroyed in 1720, when the roofing above them was removed; not long afterwards, they had obviously been irremediably damaged, for the wall was whitewashed over.

Ghiberti, who strangely enough never mentions Pietro, thought they were the work of Ambrogio alone—he, too, like Vasari looked at the images without reading the writing. Ghiberti described them in a slightly different manner, for although he mentions

the Presentation in the Temple, he talks of a Nativity instead of a Wedding of the Virgin. Since the frescoes were painted in the Hospital of Santa Maria della Scala, the fresco of the Presentation, with the child Mary climbing the steps, was probably chosen also as a reference to the name of the building; this simple game of images and words was a favourite of Ambrogio's as well, as he showed in his fresco in the Sala della Pace in the Palazzo Pubblico in Siena, where he puts a carpenter's plane in Concord's hands, to symbolize the figure's ability to smooth out all discord.

Vasari did not only get Pietro's name wrong and not realize that he and Ambrogio were brothers, he attributed the artist's most important work, the frescoes in the lefthand side of the transept of the Lower Church in Assisi, to three different painters, Puccio Capanna, Pietro Cavallini and Giotto. Whereas, on the other hand, he attributed to Pietro, and praised him lavishly for it, the fresco of the Desert Fathers in the Camposanto in Pisa, which is certainly not by him; recent scholars tend to think it is the work of Buffalmacco.

Unfortunately, we have also lost the frescoes that Vasari describes as "painted in the tribune and in the large niche of the high altar chapel" of the Pieve in Arezzo, with twelve stories from the life of the Virgin, ending with the Assumption; the Apostles were painted life-size and Vasari comments "in this he showed greatness of spirit, and was the first to try and make art more monumental. . . In the faces of a choir of angels flying about the Madonna with graceful movements so that they appear to be singing while dancing, he portrayed a truly angelic and divine joy, for he has made all the angels, while playing different instruments, look at another choir of angels, on an almond-shaped cloud, carrying the Madonna up to heaven. . ." Here, Vasari has succeeded in grasping some of the characteristics of Pietro's art, in particular the way he conveys the complexity of relationship between figures by their eyes (we will notice this above all in the Madonna and Child paintings, where both figures are always seen as intent on a silent conversation) and his ability to give expressions to the faces, smiling or in pain in a natural way, without conveying feelings solely through an over-emphasized and clumsy mimicry which, in the work of earlier artists, resulted in mask-like grimaces (like, for example, all those St Johns kneeling at the foot of the cross, with faces contorted and distraught). And, still according to Vasari, it was thanks to the beauty of these frescoes that Pietro was awarded the commission of painting the altarpiece for this same

Pieve; this painting we still have, and we will be talking about it shortly.

We do not even know Pietro's dates: he was born around 1280 and died around 1348, the year of the Black Death, which probably killed his brother Ambrogio as well. The few documentary sources that mention him give us no biographical information whatsoever. In 1342 he bought some land for Cola and Martino, the orphan sons of the sculptor Tino da Camaino; this fact backs up even further the stylistic similarity noticeable between the Madonna and Child in the Carmine altarpiece (1328) and Tino da Camaino's Madonna for the tomb of Bishop Antonio Orso (died 1321), now in the Museo dell'Opera del Duomo in Florence.

This is not the only instance of the influence of sculpture on the work of Pietro, for on several occasions he appears to have studied in depth the work of Giovanni Pisano. In the polyptych of the Arezzo Pieve mentioned above, we can easily distinguish the influence on Pietro of Giovanni's sculptures on the facade of Siena Cathedral. (This is another feature that he has in common with his brother Ambrogio, who was an ardent admirer of classical art and loved to draw statues; for example, Ghiberti tells us, he made a drawing of a Venus by Lysippus which had been discovered by chance in Siena by workmen digging the foundations for the Malvolti palaces.) Since our documentary information is so scarce and so discontinuous — and Vasari is certainly no great help, for he never bothers even to give the dates of dated paintings — we shall proceed by examining the four surviving works that are datable with certainty, either from inscriptions on the paintings themselves or from documentary sources; in this way we shall be able to establish a valid stylistic development.

Dated Altarpieces
The Arezzo Polyptych

The polyptych that Pietro Lorenzetti painted in 1320 for Bishop Guido Tarlati is still today kept above the high altar of the church of Santa Maria in Arezzo, commonly called the Pieve or parish church. Unfortunately, the predella has been lost. In the contract for this painting the artist is referred to as *Petrus pictor, quondam Lorenzetti qui fuit de Senis* (Pietro, painter, the son of the late Lorenzetti who was from Siena). Giovan Battista Cavalcaselle, the art historian who first really discovered Pietro's talents, stresses the importance of this painting, as one of the main works of the first half of the 14th century.

In the centre, the Madonna gazes tenderly at the Child, who is portrayed in a mood of calm trust and faith; he rests one hand on his mother's shoulder, while with the other he is holding her veil. The lower part of the Virgin's body is parallel to the background plane, whereas the upper part, at the level of her shoulders, is slightly twisted, in a movement that is reminiscent of Giovanni Pisano's Madonna done for the facade of Siena Cathedral; with this movement, the figure of the Virgin makes room for the Child, and the faces are seen in three-quarter profile. The artist has also portrayed, from left to right, Saints Donatus, John the Evangelist, John the Baptist and Matthew.

The Baptist indicates the Christ Child with his thumb: this gesture was never used before and became typical of Pietro's painting whenever he wanted to emphasize the relationship between two characters, in this case between he who announced the coming of the Saviour and Christ who, made flesh in the Virgin, fulfilled that promise. The entire sequence is admirably constructed; the continuity between the different panels is achieved by the joining wings of the angels, arranged in pairs in the spandrels of the individual sections: here we can distinguish without doubt the influence of Duccio's great altarpiece (now in the Museo dell'Opera in Siena). Yet, at the same time, the figures are very firmly and solidly placed in space, in a way that is more reminiscent of Giotto: and, in fact, John the Baptist and John the Evangelist, who are placed diagonally and in converging lines towards the Madonna, a line emphasized by their hand-pointing gestures, suggest the depth of a third dimension, which almost creates an ideal throne for the Virgin.

This horizontal pattern is counterbalanced by the small pilasters dividing the individual sections and also by the complex architectural shapes surrounding the upper figures. Again from left to right, we have Saints John, Paul, Vincent, Luke, James Major and Minor, Marcellus and Augustine. They are arranged in pairs, and each pair takes up the same amount of space as one saint in the lower section; in the spandrel in the middle of this sort of diptych, in a roundel, we have the figure of a prophet who is looking towards the Annunciation in the panel just above the Madonna and Child. (In this way Pietro maintains and repeats the

1. The Arezzo Polyptych, detail
Annunciation and Madonna and Child
Arezzo, Santa Maria

4

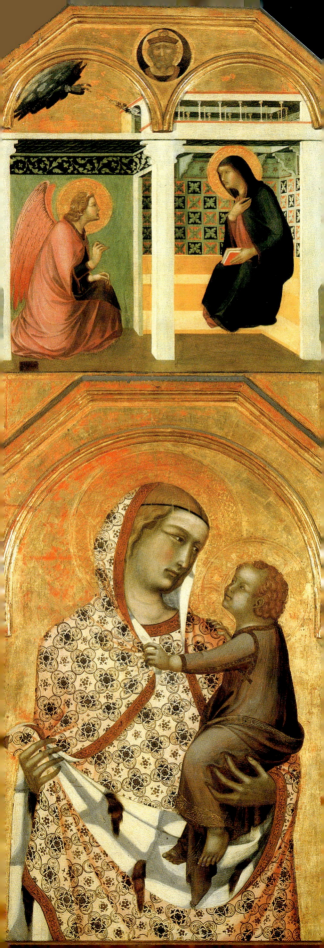

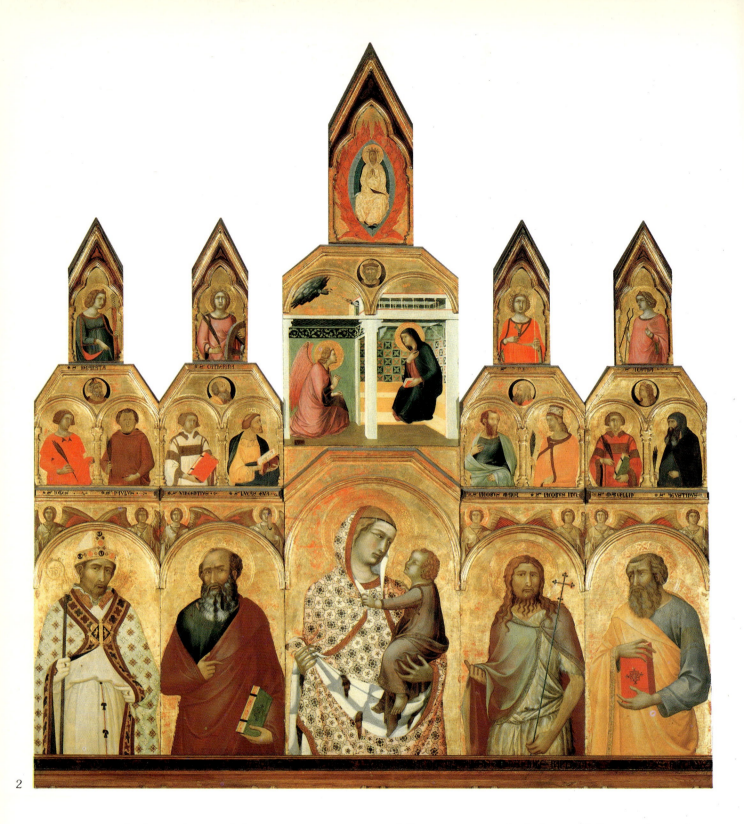

2

same pattern of relationships and the same converging of figures towards the central element he had created in the lower part of the polyptych.) Each pair of saints is then surmounted by a female saint, this time placed within a tall and narrow trefoiled arch.

1 In the Annunciation we find another characteristic feature of Pietro's art, that is his tendency to use elements outside the painting itself, like the small pilasters and the arches of the frame, as an integral part of the composition; here, for example, they are used as the front wall of Mary's room. But the Angel is placed in

a different room, which has a different depth from Mary's room; this way, not only does Pietro manage to create movement of volumes, but the scene also acquires greater dynamic quality since the Virgin is placed in a real relationship only with the ray of God's light that enters her room, and the Angel is quite clearly just an intermediary, who is not really taking part in the dialogue between the Virgin and God. The Assumption is the final, triumphal episode in the life of the Virgin, who rises to heaven to be joined once again to her divine Son.

3

2. The Arezzo Polyptych
cm. 298 x 309
Arezzo, Santa Maria

3. The Carmine Altarpiece, detail
Madonna Enthroned with St Nicholas and the
Prophet Elijah
cm. 169 x 148
Siena, Pinacoteca Nazionale

The Carmine Altarpiece

In the Pinacoteca in Siena we can today see almost
the entire polyptych, which has been dismantled and
reassembled several times, commissioned by the
Carmelite monks of Siena between 1327 and 1328.
Pietro had certainly finished it before 26 October
1329, when the Commune of Siena, following a re-
quest made by the Order, granted a contribution of
fifty Lire with which the monks could finish paying the
artist, for he was refusing to deliver the painting before

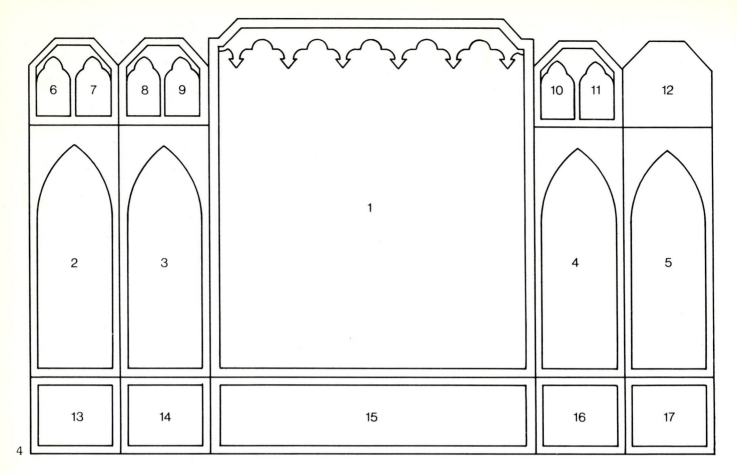

having received the full payment. In view of this, the date on the painting itself, near the signature, must be interpreted as MCCCXXVIIII, rather than MCCCVIII as it appears today. This episode, involving the political establishment of Siena, gives us an idea of the prestige that Pietro held at the time, and how high his prices were, since the Carmelites had agreed to purchase his painting for 150 gold florins, a considerable amount of money at that time.

The altarpiece remained in the church of San Nicolò in Siena, that is the church of the Carmine, for about two centuries; then, with the changing artistic fashions, it was relegated to the little church of Sant'Ansano a Dofana, where it was subjected to some slight alterations. The prophet Elijah, to the right of the Virgin, was changed into a St Anthony Abbot, the patron saint of animals and therefore more suited to a country oratory; part of the predella was also painted over with stories from the life of St Ansano. Other parts of the polyptych stayed in the Carmelites' monastery in Siena, but since the painting was by this stage already dismantled these other sections were dispersed and sold to antique dealers. One cusp, showing St Andrew and St James, was found by Venturi in 1945, and is now in the museum of Yale University in New Haven; two side panels, showing St John the Baptist and the prophet Elisha, were recognized as being part of the polyptych by Federico Zeri in 1971, and are now in the Princeton University Art Museum in New Jersey. The sections that stayed in Siena and the part that had been transferred to Dofana have now been reassembled and are on ex-

hibit in the Siena Pinacoteca.

The subject-matter of the polyptych is very specific and, for the period in which it was commissioned, even quite provocatory. The Carmelites are a mendicant Order, founded around the 12th century by a group of Crusaders who had settled on Mount Carmel in Galilee "following the example of the saintly and solitary prophet Elijah, near the spring that bears the name of Elijah," as James of Vitry recalls in his *Historia Orientalis*. (Elijah is connected to Mount Carmel because that is where he defeated the prophets of Baal). The Carmelites built a little church dedicated to the Virgin Mary on this mountain, and made her their patron and protectress. They claimed to be the descendants of Elijah and his successor Elisha through "the sons of the prophets who continued to live on Mount Carmel"; they even claimed to have received approval by the Virgin Mary herself. Still according to the legend, the Carmelite hermits had been baptised by the Apostles: this made their Order a sort of bridge between the two worlds, of the Old and the New Testament. The first official approval of the original nucleus of hermits was given around 1210 by the Patriarch of Jerusalem, Albert; this was followed by papal approval in 1226 and by various other instances of papal assent until the hermits became an actual Order. After the fall of the Latin Empire in 1261, the Order was forced to move from the Holy Land to the West, where it was united to other mendicant Orders. In 1286 Honorius IV changed the Carmelites' habit, which had originally been of white and dark stripes (in memory of Elijah's cloak that had been charred by the

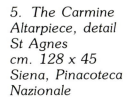

5. The Carmine
Altarpiece, detail
St Agnes
cm. 128 x 45
Siena, Pinacoteca
Nazionale

6. The Carmine
Altarpiece, detail
St Catherina of
Alexandria
cm. 127 x 46
Siena, Pinacoteca
Nazionale

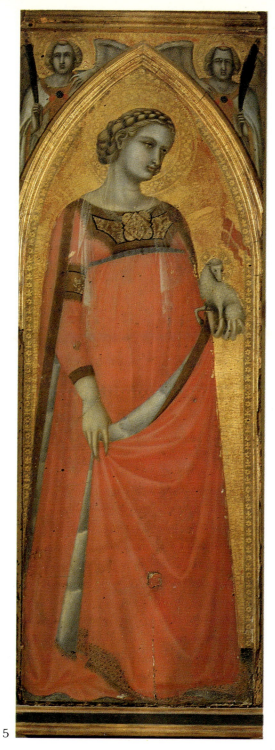

5

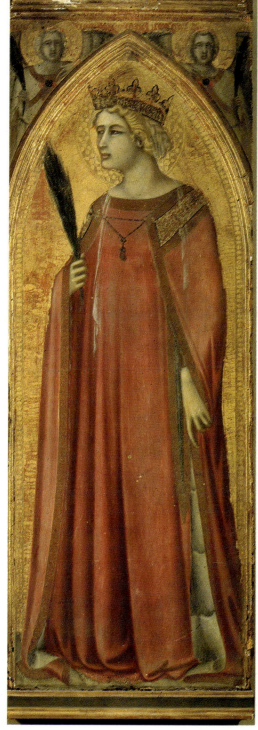

6

flames as he rose to heaven on his chariot of fire); the new habit was pure white and was also the symbol of the reconfirmation of the new Order. Papal approval was renewed by Boniface VIII in 1298 and by John XXIII in 1317 and 1326; on this last occasion the Carmelites were included in the papal bull *Super Cathedram*, already extended to the Franciscans and the Dominicans. These continuous appeals to the authority of the pope indicate the difficulties encountered by the Order, for the other mendicant Orders constantly questioned the historic truth of their descendance from Elijah and Elisha; this situation continued until 1447. I thought it was necessary to give a summary of all these facts in order to understand the complex message — almost a challenge made by the Order — of this altarpiece.

The polyptych is divided into two sections: in the cusps and the main panels we find the "historic" tradition of the Order, whereas the predella illustrates the "modern" events. In the centre of the altarpiece is the Madonna Enthroned, surrounded and crowned by angels, with St Nicholas, patron of the church of the Carmine, to the left, and the prophet Elijah, wearing a Carmelite habit and unrolling a scroll on which is inscribed a verse from the Bible (I. Kings, 18: 19): *verumtamen nunc mitte et congrega ad me universum*

9

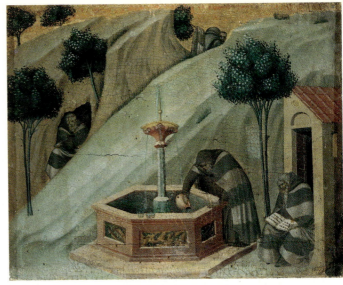

7

8

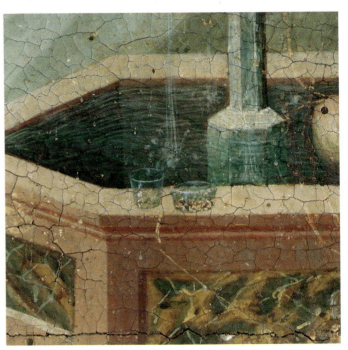

9

Israel in monte Carmelo et prophetas Baal quadrigentos quinquaginta. . . (Now therefore send, and gather to me all Israel unto Mount Carmel, and the prophets of Baal four hundred and fifty. . . which eat at Jezebel's table). It is with these words that Elijah addresses Ahab, challenging Baal's prophets; it is with these words that Elijah proves that his is the true God; this quotation was therefore extremely relevant to the current situation, for it referred to the acceptance and credibility that the Order was demanding. The Child, from the throne, turns towards Elijah in a gesture of approval, stressed also by the way John the Baptist in the panel immediately next to the main one (now in Princeton) indicates with his thumb. The Baptist has often been called the second Elijah, and iconographically they are very much the same type: both ascetics in the desert, emaciated by long fasts, clothed in rough animal skins. This assimilation is the result of Malachi's prophecy, according to which the coming of the Messiah will be preceded by Elijah, who will come down from Paradise to prepare His way (therefore, Elijah is the precursor of the precursor of Christ, who is John the Baptist). In the panel to the left, next to the group of the Madonna and Child, is the prophet Elisha (also, unfortunately, now in Princeton), with a scroll in his hands and wearing the Carmelites' white habit. The words on his parchment are those of II. Kings (2: 11-1): *ascendit Helias per turbinem in caelum; Heliseus autem videbat et clamabat: Pater mi, pater mi, currus Israel* (and Elijah went up by a whirlwind into heaven. And Elisha saw it, and he cried, My father, my father, the chariot of Israel). It is the moment when Elisha is acknowledged successor of Elijah, and he takes up the master's mantle which had fallen from him on his flight to heaven.

In the Carmine altarpiece, Elisha is seen as the second founder, the first link in that long chain that connects the biblical prophets, generation after generation, to their last descendants, the Carmelites. The 5,6 two outside panels show Saints Agnes and Catherine. Lorenzetti's altarpiece stood in the main chapel of the church, the Chapel of the Arte della Lana, or Wool

*7. The Carmine Altarpiece, detail of the predella
Dream of Sobach
cm. 37 x 44
Siena, Pinacoteca Nazionale*

*8, 9. The Carmine Altarpiece, detail of the predella
Elijah's Well
cm. 37 x 45
Siena, Pinacoteca Nazionale*

*10. The Carmine Altarpiece, detail of the predella
Handing Over of the Rule
cm. 37 x 154
Siena, Pinacoteca Nazionale*

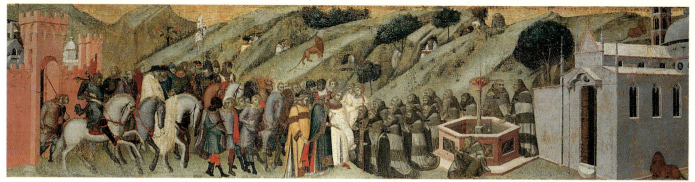

10

Guild, which explains the connection with Agnes, interpreted by a great flight of etymological fancy as meaning *agnus* or lamb, in other words the animal that provides wool. As far as Catherine is concerned, her presence is justified both because she is the patron saint of wool carders and also because she was of Oriental origin. The cusps, which were probably surmounted by spandrels (one cusp is lost), portray the Apostles in pairs; each pair is lovingly watched over by a prophet, once again stressing the Order's rightful heritage.

3 The Virgin, truly majestic in her ermine-lined cloak and in the austere way she looks out at the spectator, sits on an extremely wide throne, forming a large niche which accentuates the monumentality of her figure. Once again, the inspiration for this figure comes from a statue by Tino da Camaino. The hand on which the Child rests his foot almost hints at a gesture of blessing in the direction of Elijah, and therefore addressed to the Carmelite Order: the Order can thus claim the patronage even of the Mother of God.

The most innovative and interesting parts of the polyptych are, however, the predella panels, extraordinarily lively narrative scenes placed against charming architectural backgrounds and landscapes, with almost enamel-like bright colours. The first one shows
7 the dream of Sobach, the legendary father of Elijah. Sobach lies sleeping in an alcove of the room which the angel bursts into; the room is perfectly empty except for a towel hanging from a rod, the windows either open or half-shut, the row of arches that allow one to see through to the stairway, the slim columns of the loggia above the room —all these communicate wonderfully the idea of a silent but bright dream.

8 The following panel shows a miniature Thebaid, for it illustrates the joy and sweetness of solitude. The medieval desert is here transformed into barren rocky hills, softened by trees and by occasional unexpected clumps of grass, against which are placed the huge figures of the hermits, intent on their simple chores or engrossed in their reading. The life-giving centre is the sculpted fountain; on the edge of the fountain there
9 are two glasses full of water, a masterly touch, which makes Pietro, we might say, the innovator of a new genre in painting, the still life.

In the rectangular panel in the centre of the predella
10 there is a large group witnessing the handing over of the rule from Albert, Patriarch of Jerusalem, to St Brocard, the first Carmelite prior. The contrast be-

11

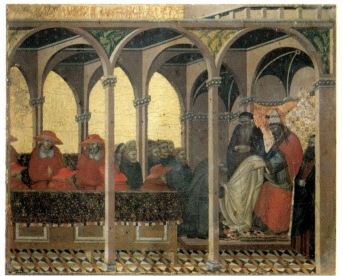

12

11. The Carmine Altarpiece, detail of the predella
Approval of the Rule
cm. 37 x 41
Siena, Pinacoteca Nazionale

12. The Carmine Altarpiece, detail of the predella
Honorius IV Approves the New Habit
cm. 37 x 45
Siena, Pinacoteca Nazionale

11

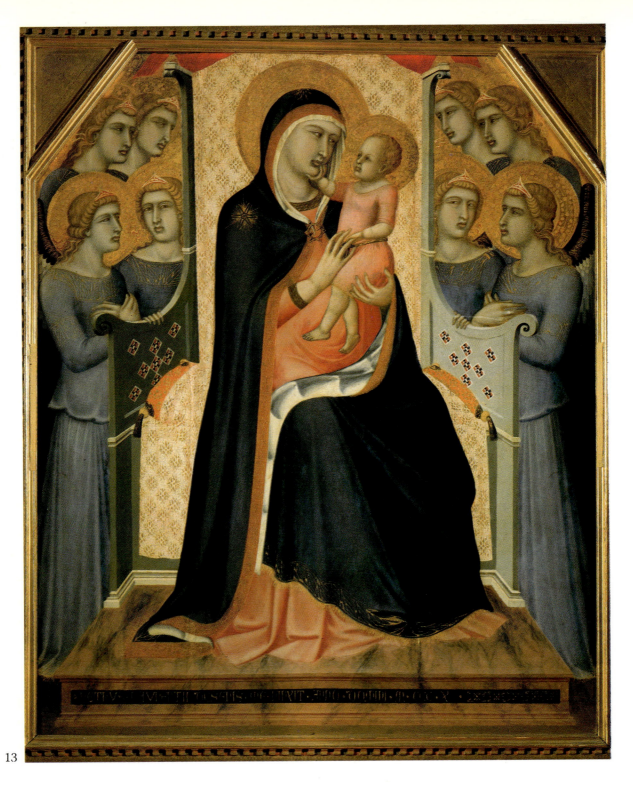

13

tween the smooth hilltops, with the solitary wild animals and isolated flowers, and the cluster of figures in the foreground is intentional. In the group scene Pietro gives us an example of his ability as a miniaturist, capable of giving each figure his own individual features, gestures and poses. The procession of people coming out of the red city walls of St John d'Acre to reach the bluish church of the Carmelites is like a visual bridge between two epochs, the age of the glorious and almost mythical Anchorites of Galilee and the modern age, characterized by the return to the West and the acceptance within the official structures of the Church. This is the subject of the last two panels. In the first we see the pope, surrounded by the 11 cardinals, approving the Carmelite rule (again this emphasizes the legitimacy of the Order, for three popes have come down from heaven to confirm the validity of the historical tradition). In the second, Honorius IV 12 replaces the striped Carmelite habit with the new white one. The architectural background is basically the same one that Ambrogio will use two years later in his fresco in the church of San Francesco in Siena, showing Boniface VIII accepting St Louis as a novice. In the 72 panel illustrating the institution of the new habit there

14

is an interesting cubic loggia painted above part of the Curia: it expands the spatial background and gives depth to the immobile gold sky. As far as the subject-matter of the previous panel is concerned, it is possible that the pope portrayed is neither Honorius III nor Honorius IV as he is normally identified, for this would not justify the three popes descending from heaven to help him. The final solemn approval of the Order was given by John XXIII in 1326, and we know that the polyptych was commissioned in 1327; we can there-fore suggest that this was the occasion for commission-ing such an openly propagandistic painting.

The Madonna and Child in the Uffizi

This painting is signed and dated 1340; the predella, described by Vasari, has been lost. In this work, Lorenzetti shows his ability to provide constant varia-tions on the subject of the Mother and Child, as well as his keen powers of observation of children and their little gestures. Jesus grabs Mary's chin with one hand, while with the other he holds a finger of the hand that is supporting him. In this painting, Pietro has concen-trated primarily on the light effects, showing, for ex-

13

13

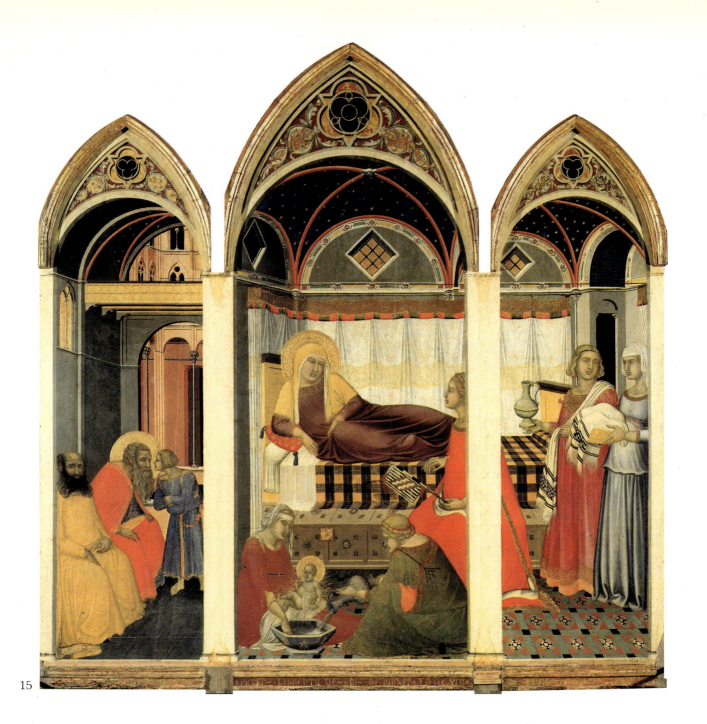

15

15. Birth of the Virgin
cm. 188 x 183
Siena, Museo dell'Opera del Duomo

The Birth of the Virgin in the Museo dell'Opera in Siena

ample, one side of the throne bathed in bright sunlight, while the other stands in deep shadow. The large patches of solid colours give the figures added volume. Pietro does not, however, stop experimenting with new effects in order to draw the attention of the observer: he makes the Virgin's cloak on the lefthand side fall straight down, without respecting the horizontal plane of the throne which should have interrupted the vertical lines; this creates an ambiguous image, that makes us spectators slightly uneasy.

We have come to the last of the dated paintings, completed in 1342, but we know from our documentary sources that it had been commissioned as early as 1335. The frame of the triptych has here become part of the architectural construction of the painting itself, which is full of new and interesting solutions. The slanted perspective, used in order to give the foreshortenings greater depth, is purposely arranged so as to have different points of view and very daring connecting passages: if we take the central section of the triptych as the main point of view, the lefthand and righthand sections appear to be opening outwards, in a fan

15

16. Madonna and Child ("The Monticchiello Madonna")
cm. 68 x 46
Siena, Pinacoteca Nazionale

17. St Margaret
cm. 55 x 33
Le Mans, Musée Tessé

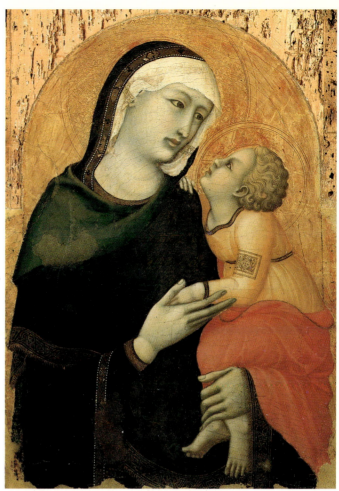

16

shape. This allows the figures at the outer edges of the painting to move about freely in a wide space, instead of being crammed in by the walls of the room and the pilasters supporting the ceilings, as they would have been had the laws of perspective been respected. The room where Joachim is sitting, anxiously leaning forward to hear the news from the young boy, opens at the back onto another room (beyond which we can see a courtyard), which has more depth than the one in which St Anne lies, surrounded by her friends and midwives. The details, described by Pietro with loving care, are quite justly famous: the clean towels with the lovely lozenge decoration, the black and white straw fan held by the woman seated next to the bed, the bowl with floral decorations where the water for the infant's first bath is poured, and the tartan blanket whose large checks are almost like a continuation of the lively floor tiles. Anne, lying on her bed, is strongly reminiscent, as Enzo Carli pointed out, of Arnolfo di Cambio's Madonna of the Nativity, formerly on the facade of Florence Cathedral, while the midwife pouring water from the jug, seen in three-quarter profile, is quite definitely Giottesque. Solidity of volumes and great attention to details are blended in Pietro's work with splendidly flowing lines and extremely elegant drawing. Yet, there is never a figure that appears too polished, and therefore distant; on the contrary, they all communicate an intense inner life. See, for example, the gentle Madonna from the Pieve dei Santi Leonardo e Cristoforo in Monticchiello, now in the Siena Pinacoteca. The face of the Child, who is almost exaggeratedly turned around so as to meet his mother's gaze, resting his hands on her shoulder in a pose of complete abandon, blends with the elaborate depiction of the Madonna's hands holding Jesus's little legs and his hand in an abstract play of lines and barely suggested chiaroscuro. The same can be said of the lovely painting of St Margaret, now in the Gallery at Le Mans. Her right hand is bent backwards and, with daring foreshortening, fits into the niche in the slightly raised cloak, while her dress opens up on her breast, allowing us to see a precious embroidered border, weighed down by a row of gold buttons, shining like a bunch of gold blackberries.

16

17

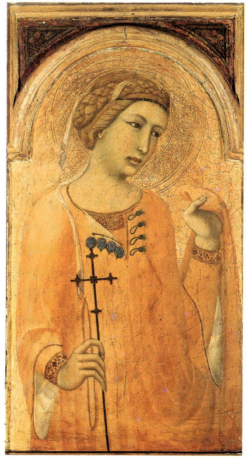

17

The Frescoes in the Lower Church at Assisi

It was Cavalcaselle in 1864 who first attributed the frescoes in the Lower Church at Assisi to Pietro Lorenzetti, and this attribution is now universally accepted. The great art historian suggested that they dated from 1320, and recent scholars tend more or less to agree. Hayden Maginnis, who has studied the intonaco and the different workdays (that is the portions of the fresco that were painted at each session), has recently established that the cycle was begun from the ceiling and that work progressed moving downwards; in her analysis, she also took into consideration the information resulting from Leonetto Tintori's restoration work. The cycle was painted in a single pictorial campaign and must have been completed before the serious political upheavals that lead to the expulsion of the Guelphs from Assisi in 1319 and the institution of the violent Ghibelline government led by Muccio di Ser Francesco from Bologna.

The first of the six stories from the life of Christ *ante mortem* frescoed on the ceiling of the left arm of the transept is the Entry into Jerusalem; this is followed by the Last Supper, the Washing of Feet, the Capture of Christ, the Flagellation and the Road to Calvary.

18 The fresco of the Entry into Jerusalem is a collection of extraordinary inventions, starting from the procession of the Apostles meeting the inhabitants of the city, who have come to see Christ; they are structured in two groups, like the two sides of a very wide angle at the summit of which, in the point closest to the onlooker, stands the Saviour, slowly making his way riding on the little donkey. Inside this angle there is another one, perfectly parallel to the first, but smaller; it consists of the clustered buildings of Jerusalem, held together by the steep walls shown in daring foreshortening, and continued by a broken but enveloping line that leads our gaze to beyond the city gates. The architectural composition thus almost appears to be pushing Christ on, to be forcing him towards the spectator, while at the same time it expands the three-dimensionality of the space. The sky is no longer an immobile dull background, for a transparent blue can be seen through the two-light window and the single-light one in the pink tower, between the tall arches of the greenish temple, amidst the crenellations of the slim twisted colonnettes of the lilac tower (notice also these imaginative colour harmonies, so unpredictable and yet so perfect). Each Apostle is given his own individuality, like for example the one to the right of Judas (portrayed here already without a halo, and with a stern expression, wrapped up in the red cloak which both isolates him and makes him stand out from the others), who turns to the left, distracted by the children collecting olive branches on the hillside. From Judas's red cloak our gaze is drawn to Peter's yellow one, right next to him, and then to Christ's very bright

blue one; then down to the large pink patch of the young boy bending over to stretch out his cloak, marking the last element of this collection of colours begun with Judas's red mantle. The young boy marks the beginning of another wave; the first was formed primarily by the variation of strong patches of colour against the rather dull background of the procession, made up of sombre colours, in which Pietro Lorenzetti has created his volumes according to Giotto's models; the second, on the other hand, is formed by the flowing and elegant lines of the group of children taking their costumes off, with the rhythms of calm and orderly dance (and here, too, Pietro does not neglect realistic details lovingly rendered, like the little boy whose head appears between the two youths in blue, almost as though he was peeping out from the curtains of a stage).

Ambrogio will remember this group clearly when he comes to paint the group of the dancing girls in the 89 Good Government, with the head of a blonde child just barely peeping out from the doorway of his father's cobbler shop.

In the Washing of Feet, Lorenzetti overcomes the 19 difficulty of a real arch "by arranging the scene," as Enzo Carli points out, "on two different levels: the upper one shows us the Apostles seated behind a balustrade, alternately with their back to us or facing us, while the actual Washing of the Feet in the lower lefthand part becomes the dominant event." Our attention is drawn to the lively discussion between the kneeling Christ and the Apostle, who raises his hand to his head in a gesture of determined refusal, by an oblique line which ideally goes from the shoulder and the face turned to the left of the Apostle with his back to us, obviously turning because he is attracted by the discussion, to the black sandal of the Apostle nearby, who is getting ready to have his feet washed. The gesture of the Apostle holding his chin with a thoughtful air is exactly the same as the knight in the Crucifix- 26 ion (on the lefthand wall of the transept), who lowers his gaze to the feet of the Good Thief: this observation was first made by Maginnis, together with several others which for reasons of space we cannot mention here, but which are evidence of the stylistic continuity and chronological proximity between the stories of Christ before his death, painted on the ceiling, and those from after his death, painted on the walls. (Some critics, in fact, such as Carli for example, date the latter between 1324 and 1328).

The Last Supper has a composition that was obvi- 20 ously very clearly thought out, starting with the hexagonal pavillion painted in overturned and widened perspective: the focal point is marked by Christ and John, who stand like a pearl between the valves of a half-opened shell, that is the beams of the ceiling

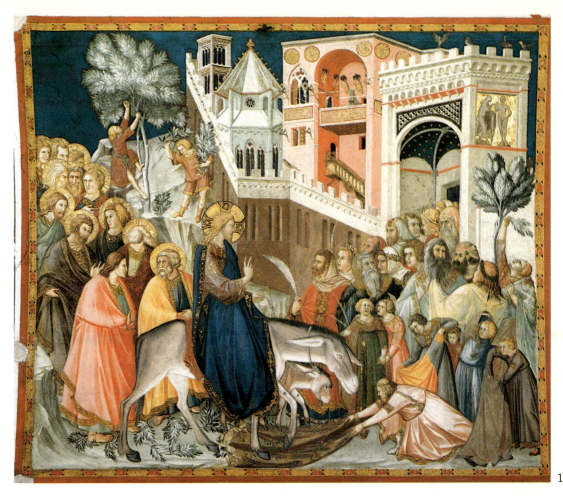

18. Entry into Jerusalem
Assisi, Lower Church

18

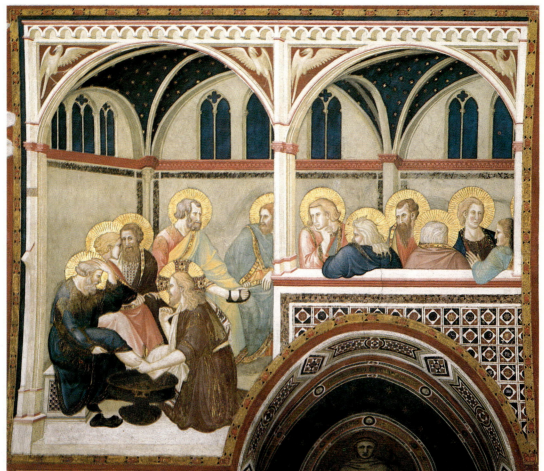

19. Washing of Feet
Assisi, Lower Church

19

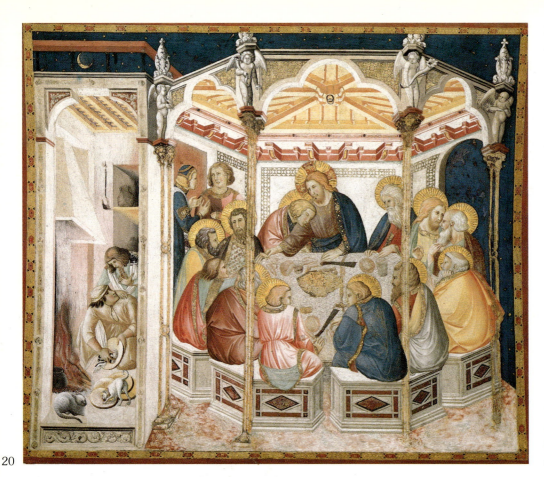

20

21. Last Supper,
detail of the kitchen
with two servants
Assisi, Lower Church

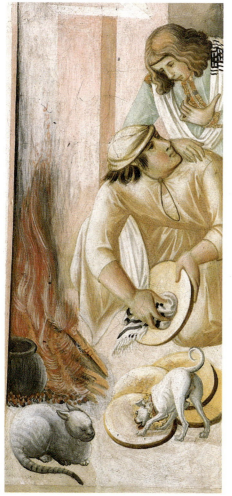

21

spreading outwards like sunrays and the decreasing group of the Apostles. To the left we can just see a kitchen, a real piece of virtuoso perspective, with its slanting chimneypiece and the niches containing the utensils, a little patch of "still life" that Pietro so liked to place in his works. The connection between the two rooms is made by the pointing hand of the servant 21 leaning on the shoulder of his kneeling companion, who is scraping the plates next to a blazing fire. The servant is pointing to a lavishly dressed man who is standing talking to another figure, wearing more modest clothing. This is probably a conversation between the master and the servant whom Christ had ordered the Apostles to follow in order to ask his master for permission to celebrate the Passover. The two men are therefore presumably discussing the servant's encounter with the Apostles.

This kitchen scene is normally considered a great innovation, and interpreted as the insertion of a realistic detail in a subject so full of symbolic implications as the Last Supper. But the importance given to the high flames in the fireplace, used as the source of light within the painting, hints at the possibility of a different meaning, more in tune with the gravity of the scene: it is because of the light shed by the fire that the figures are alternated in light and shadow. (Incidentally, two details that really are innovative are the shadows of the sleeping cat and of the dog dashing over to lick the plates piled on the ground). A recent interpretation by Carra Ferguson O'Meara suggests that this genre scene is the visualization of a theological message con-

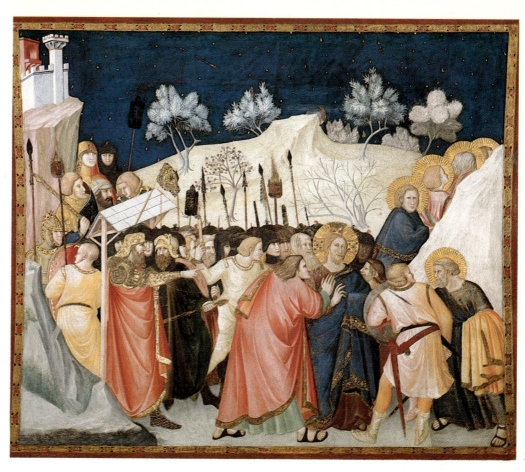

22. Arrest of Christ
Assisi, Lower Church

22

cerning the nature of Christ's sacrifice on the cross, and the repetition of this sacrifice in the Eucharist; according to the Christian commentators of the Old Testament all episodes containing sacrifice with fire, ritual victims and ritual immolation sites were to be interpreted as symbolic references to the Crucifixion and the Eucharist.

Christ, dying at Easter time, becomes the Easter lamb of the new era, the Eucharist, the unleavened bread, says Thomas Aquinas for example. In the Last Supper the celebration is the Hebrew Passover, and we can perhaps say that the last live victim has been roasted. These two rooms can therefore be seen as representing the sacrifice in the Old Testament, where the victim is the real lamb (the kitchen), and the sacrifice in the New Testament, the new Easter with the spiritual lamb (the room of the Last Supper). Even the little dog has a hidden meaning. St Bonaventure in his third sermon dealing with the Lord's Supper compares those who only desire real flesh rather than the flesh of the Immaculate Lamb to dogs, who must be denied access to the Eucharistic table. We know of the extraordinary abilities of symbolic exegesis developed by medieval ecclesiastical commentators, who were not daunted even by the most explicitly erotic descriptions in the Song of Songs which they managed to transform thanks to their ingenious interpretations into perfectly chaste images of Christ and the Church; so it is possible, in theory, to interpret the presence of a fire as a sign of a hidden reality. But there must not then be any elements that do not fit

23

23. Judas Hanging Himself
Assisi, Lower Church

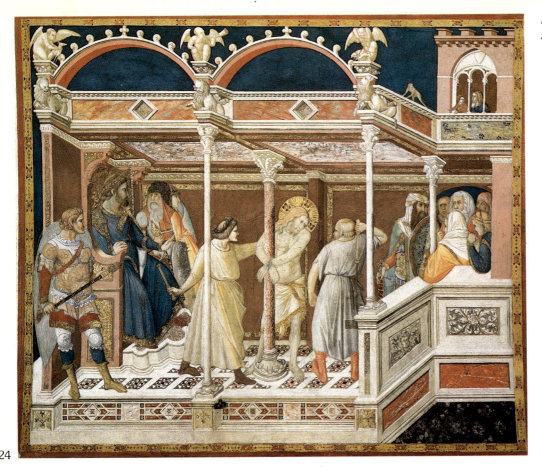

24

into that interpretation, for if we apply the method of a continuous concordance, there must be consistency between reality and symbol. It is not possible to interpret the dog as a sinner, and then see the cat sleeping next to him purely as a decorative element; just like we cannot think that the towels with which the servants are cleaning the plates are liturgical shawls for the sacrifice, for the Apostles are not wearing them (and, in any case, why should they reappear, exactly identical, in the scene of the Birth of the Virgin, where they are used to cover the baskets of food brought to St Anne by her friends?). In other words, this theory, rather more ingenious and imaginative than it is persuasive, doesn't hold.

Another extraordinary innovation of Pietro Lorenzetti's is how he draws the onlooker's attention to the passage of time. He is possibly the first artist in the history of medieval painting to attempt this, and he succeeds in giving greater dramatic power to the scenes telling the story of the last period of Christ's earthly life. Outside the brightly lit pavillion, where the Apostles have gathered, it is night time, the stars are shining and the moon has just risen. The same moon that is inexorably setting in the next scene, the scene of the Arrest of Christ, marking the high speed at which events are following on each other. The moon's movement in the sky also emphasizes the connection, already implicit in the story of the Passion, between one episode and the next. In the Arrest of Christ the various characters move in a circular pattern, entering from the rocks stage left and exiting — the movement

of the figures and the layout of the barren mountain scenery quite literally bring to mind a stageset — to the right disappearing behind the rocks. Against the compact background made up of the heads of the soldiers, hidden away inside their sinister armour, stands out the loosely arranged group of Christ and Judas, who looks huge in his wide red cloak, and Peter, who is in vain being held back by a soldier dressed in pink as he cuts off Malchus's ear. Christ's head, portrayed frontally, is therefore placed at the summit of an ideal triangle, the sides of which are formed by the faces in profile, expressing very different emotions, of Judas and Malchus; this triangle continues in another ideal triangle, this time overturned, where the summit is the back of the head of the soldier dressed in pink, and the other two points are the faces in profile of Malchus and Peter. The whole scene is masterfully isolated by the empty space Lorenzetti leaves between Christ and the soldiers who are about to arrest him but haven't yet arrived; the dramatic sense of the event is increased by the fact that it has been caught just an instant before its final conclusion, suggested by the imperious arm of the centurion, still distant yet so imminently threatening.

Judas's Betrayal is not illustrated by the kiss, as is customary in traditional iconography, but by a much more emotional and dramatic representation: the scene of the Apostles fleeing, abandoning their master, running off and bumping into each other like a flock of frightened sheep, hiding their faces behind the rocks to the right.

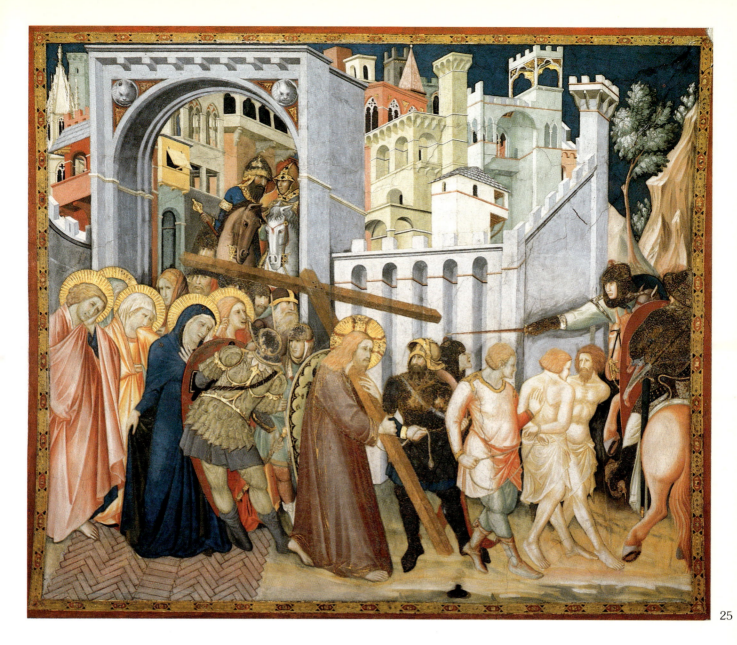

The following scene is the extraordinary representa-
23 tion of Judas hanging himself; this is also the only fres-
co that is accompanied by an inscription, *(I)scariotas*.
This episode is recounted only by the Gospel accord-
ing to Matthew, with the following terse line: "And he
cast down the pieces of silver in the temple, and
departed, and went and hanged himself" (Matthew,
27:5). In the Acts of the Apostles (1:15 ff.), on the
other hand, we are given another version of how Ju-
das killed himself, and it is this account that traditional
iconography normally follows. Peter is addressing the
disciples and says: "Now this man purchased a field
with the reward of iniquity; and falling headlong, he
burst asunder in the midst, and all his bowels gushed
out" (this detail is explained by the fact that many an-
cient civilizations believed that the demons resided in
the belly of the possessed person, which then burst
when he died to let the evil spirits out). Whereas nor-
mally painters, following the popular legends which
combined elements from the Scriptures with other to-
tally invented ones, show the disembowelled Judas

hanging from a fig tree (the tree that Christ himself
damned), Lorenzetti appears to be following Nicode-
mus's Apocryphal Gospel, which tells of how Judas,
in desperation, fled home to his wife to confess his
crime, in terror because of Christ's imminent resurrec-
tion; seeing no way out of this anguish, "he made a
noose with a rope and hanged himself." And, in fact,
Judas is shown hanging from a beam inside his own
house, with his neck tendons horribly dislocated: this
is a detail Lorenzetti would have picked up from the
sight of hanged men, for it was the custom to leave the
bodies hanging for days after the execution as a kind
of admonition to the population. And equally, the
spectator today will find this Judas difficult to forget,
with his body hanging inertly, entirely slackened in the
heaviness of death, his belly rent open, and his
swollen neck with his matted hair sticking to it.

In the Flagellation before Pilate — it is by now day- 24
time and the moon and the stars have disappeared —
it is the architectural background that moves the story
along. Against this background of broken lines and

21

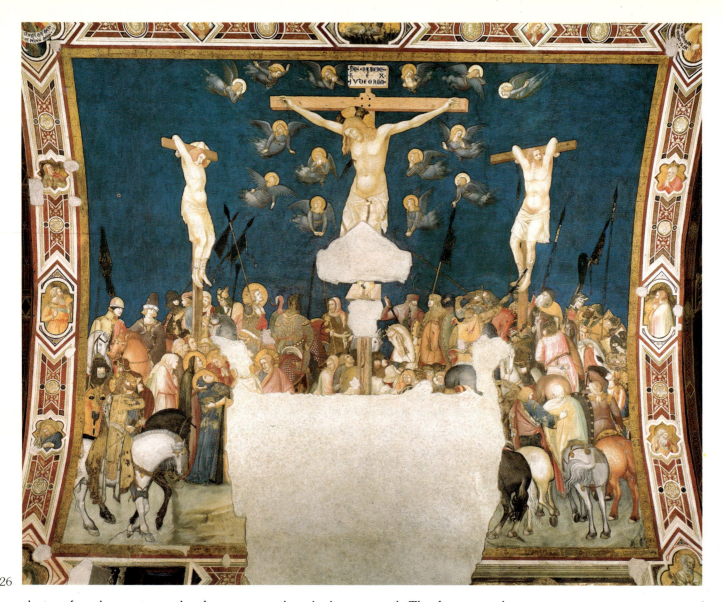

26

daring foreshortenings, the figures are placed alternately behind and in front of the slim columns, until we reach the enclosed figure of the Jew seen from behind, embracing the last colonnette on the extreme right. "He is the living link between the two adjacent rooms of the Praetorium," Enzo Carli points out. And the figurative architectural elements are also, to some extent, "living": the lions and the putti bearing cornucopias that adorn the capitals and the cornices of the room—see, for example, the lion raising his head towards the putto with the little dog above him. They are also disquieting, like the monkey who has escaped from the boy looking out from the three-light window to the right (he is perhaps Pilate's son, with his mother next to him). And precisely because they are animated by this impossible participation they communicate an impression of unease and tension.

25 But everything becomes calmer and less tense in the slow procession of the Road to Calvary, where we can observe the same circular pattern of the procession going out from the walls of Jerusalem. But here an interesting variation is afforded by the group of the Holy Women, the Virgin and St John, who appear to have joined the procession coming from a different side

road. The figures in the procession are tiny compared to the turreted Jerusalem and the two knights on horseback riding towards them from the city gate. The protagonist of this scene is the bare cross that Christ holds in his arms, placed in foreshortening; the sword of the soldier at the far right points towards it and he stretches out his gloved hand almost as though he was trying to reach it. The tragedy is drawing to a close, and is marked by the definite division created by the soldier with his back to us who is violently pushing back the Virgin; she, with a desperate but dignified gesture, pulls her cloak around herself. With one hand she clasps it round her throat, with the other she barely manages to raise the lower edge. The soldier standing with his legs apart indicates yet another separation, between the city street, paved with bricks laid in a herring-bone pattern, and the naked earth, which leads only to the sacrifice; Christ has just put his foot on it, and he is preceded by the two thieves, naked and tied together in a position which reminds us of the position of Christ in the previous scene, the Flagellation. This is a visual tie between the two scenes, introduced by the repetition of the iconographical model, used as a replacement for the changing time of

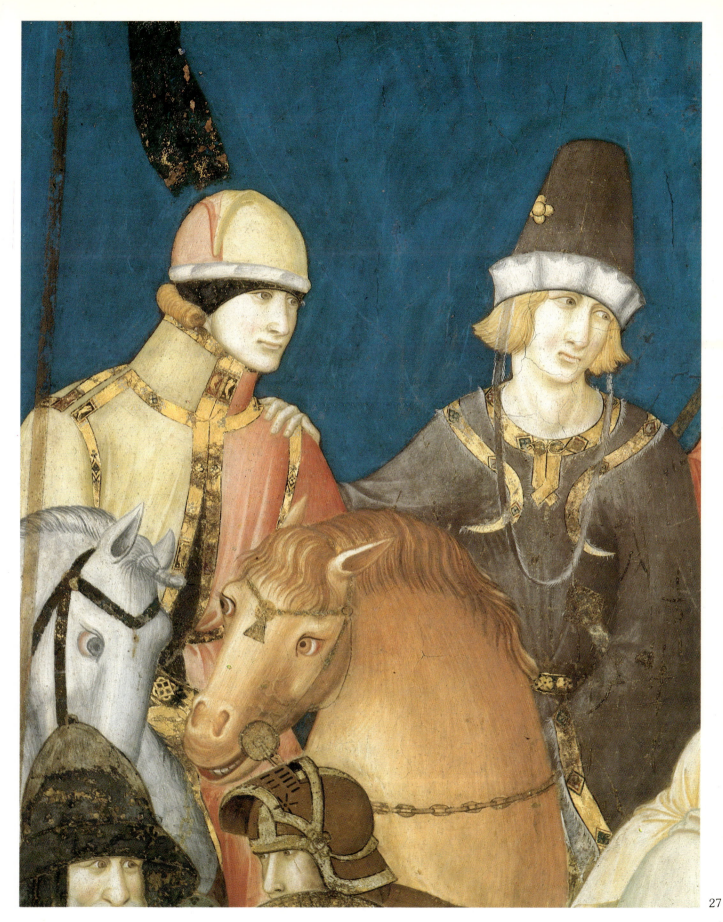

26. Crucifixion
Assisi, Lower Church

27. Crucifixion,
detail of two knights to the left of Christ
Assisi, Lower Church

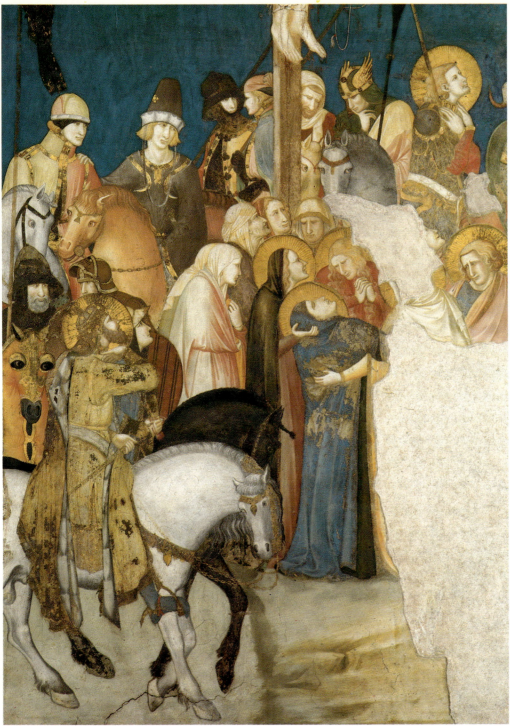

*28. Crucifixion,
detail of the two
portrayals of Longinus
Assisi, Lower Church*

28

day Pietro had used as a connecting element in the earlier stories, because by now both episodes take place in full daylight.

26 And so we come to the huge Crucifixion, on the lefthand wall of the transept. Pietro Lorenzetti has made use of the topographical layout of Mount Calvary, making the crowds and the knights on horseback arrive gradually at the foot of the crosses, so as to preserve the individuality of each character: "Here, the multitude has a face," as Cesare Brandi so rightly points out. The heads of the people furthest away from the onlooker, instead of simply forming a dark hedge, hidden behind those in the foreground, are spread out in a fan-like pattern against the horizon, arranged in groups and in a variety of gestures and poses, and yet related to each other by the exchange of looks full of expression—a variation on the theme of visual communication Lorenzetti had invented for the Madonna and her Child. Even the horses exchange looks and, with their noses pressed close together, make their way through the thronging crowd. This emphasizes the contrast with the empty void of the sky against which the three bright crosses stand out; the gold haloes of the little angels shine like the stars of a constellation, fluttering about in the sudden nightfall that has darkened the sun, announcing

27

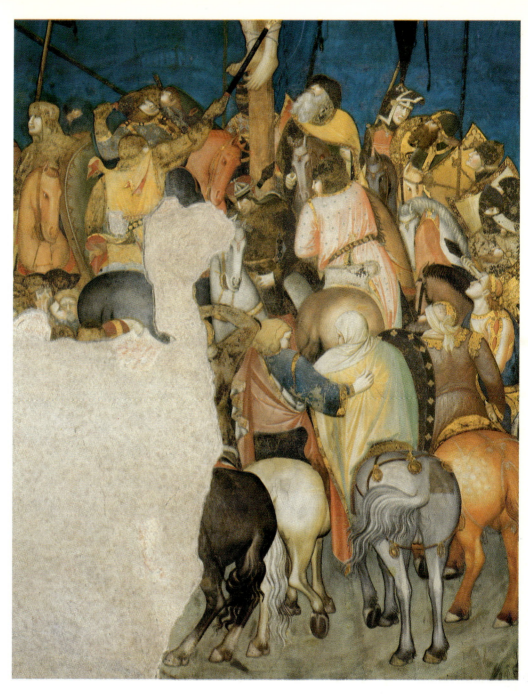

*29. Crucifixion, detail
Assisi, Lower Church*

29

the death of Christ. Next to the Good Thief, already immobile in the calm of death, we can see Longinus, with a halo, holding in his crossed arms the long spear with which he has just wounded Jesus in the side. The Apocrypha attributed the name Longinus to the spear-carrying soldier, perhaps confusing him with the centurion who, in the Gospel according to Mark, stood opposite Christ. This character, said to be blind in some versions of the Apocrypha, and therefore immediately cured by the blood that flowed from Christ's side (and this miracle appears in many paintings) over the years has actually been made a saint, with his own feastday (15 March), regardless of the fact that he is totally legendary: how unlikely that the Romans would have sent a blind man to inspect whether Christ was dead! Lorenzetti, as was frequently the case in paintings of the Crucifixion, has duplicated the charac-

ter of Longinus, who appears twice with a halo, as the spear-carrying soldier and as the centurion. The latter is the knight coming forward at the far left of the scene, with his hand on his breast as a sign of realization. He is riding a white horse, purposely cut off by the frame of the wall, a device intended to suggest a much larger scene, almost as though it was only the frame that prevents us from seeing it all.

On the next wall the cycle continues with the Deposition, possibly the most beautiful of all the frescoes, because of its masterly composition placing all the characters, with a strongly asymmetrical effect, into a pyramid off-centre to the left, leaving the visual field empty except for the huge, bare cross. From Nicodemus, who is prying out the nails from Christ's bleeding feet, to John, to Joseph of Arimathaea, to the Maries: it is an uninterrupted line that envelops them all,

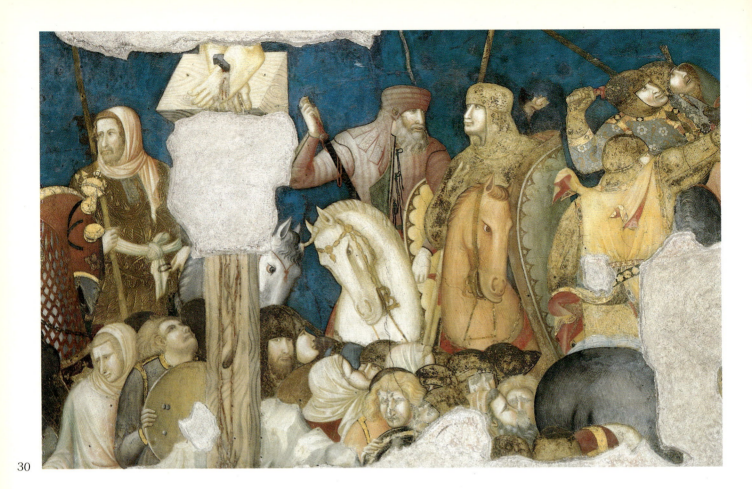

30

rhythmically scanned by the spreading grief that flows from one to the other. Each one, with gestures of love and devotion, supports the body of Christ, almost disjointed by the torture he has been through: it is almost as though it had been drawn out and stretched, and Lorenzetti portrays it like a group of broken profiles, with the side so twisted away from the rest of the body that it might have been painted according to the perspective rules of an Egyptian frieze. Also extremely beautiful is the expression of the Virgin, whose eyes are staring exactly into the closed eyes of her Son, while his blonde hair hangs down in a soft and flowing mass. Another splendid detail is the bloodstain on the rock, between Nicodemus's feet, which has just fallen from the cross, before Christ's body was removed; again, one of those indications of the passage of time that Pietro manages so skilfully to introduce in his frescoes. Here it marks dramatically the end of Christ's earthly life.

32 The peak of this tragedy lies in the Entombment: the same characters are now arranged around the tomb, and the body of the Saviour, supported by the winding-sheet which is about to envelop it, is laid out on the slab, as though it were a bed. The Virgin, stretched out alongside the body of her Son, clutches him in a desperate embrace, covering his nakedness with her cloak, as though she wanted both to protect him and to give him warmth, beyond the barriers of death. Mary Magdalene fits into the space left empty between John and Nicodemus (Lorenzetti dearly loved to fit characters into all available spaces), and as her blonde hair lifts off her face, like two heavy curtains, we notice that her expression is one of withheld and controlled grief.

And so finally we come to the Resurrection. Once 34 again Lorenzetti has made clever use of the triangular space created by the summit of the two arches, giving us a totally asymmetrical composition which expands the actual size of the wallspace. Christ is placed off-centre to the left, with one foot already firmly placed on the edge of the sarcophagus, while the lid falls backwards, to the right. The angels, carefully arranged one next to the other in close rows, are placed next to the wall frames, leaving the Redeemer as isolated as possible, in the uniform expanse of the blue sky, holding in his arms the banner, blowing in the wind. All around the sarcophagus, like a deck of overturned playing cards, the sleeping soldiers are portrayed in sharp foreshortenings; notice in particular the beautiful figure of the soldier to the left, lying disjointedly like an abandoned puppet, with his head hanging back, sound asleep, and with a row of white teeth visible through his half-open mouth; this figure is counterbalanced by the other soldier, at the far right, whose head is also hanging backwards. These two sleeping soldiers appear to open up the space of the fresco in a fan shape; the lefthand soldier is noble and elegant, with his handsome shoes and his hand resting on the splendid saddle, whereas the one to the right has coarse features and looks in general rather clumsy and crudely painted.

The last fresco of the cycle of stories from the Pas-

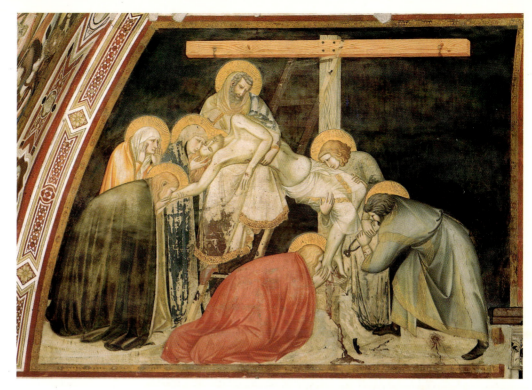

31. Deposition
Assisi, Lower Church

31

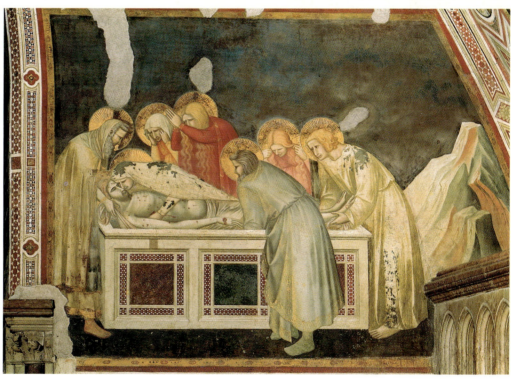

32. Entombment
Assisi, Lower Church

32

33 sion, the Descent to Hell painted on the other side of the arch, was presumably painted to a great extent by Lorenzetti's assistants, for the scene is rather unimaginative. In any case, there is one splendid detail, placed against the barren rock: the joined hands of Christ and Adam, the first man to be saved, set in contrast to the open hand, caught in a violent gesture, of Satan, whose monster-like feet are frozen in an expression of rage at his defeat. Also beautiful is the figure of Christ, shown in profile, with an expression of gravity and intensity, as tense as a taut bow.

The Master of the St Francis stories in the nave of this same church had already suggested the parallel to be drawn between the life of Christ and the life of St Francis, for he painted on the two walls, facing each other, the stories from the Passion and some episodes from the life of Francis. Here, Pietro Lorenzetti develops further this idea of the parallel and, after the scene of the Arrest of Christ, paints in the same transept the Stigmatization of St Francis. He has in a sense 35 replaced one episode from the story of the Passion, the Agony in the Garden, with this scene, and it fits in in perfect harmony. We must not forget that in the first biography of Francis by Thomas of Celano, written

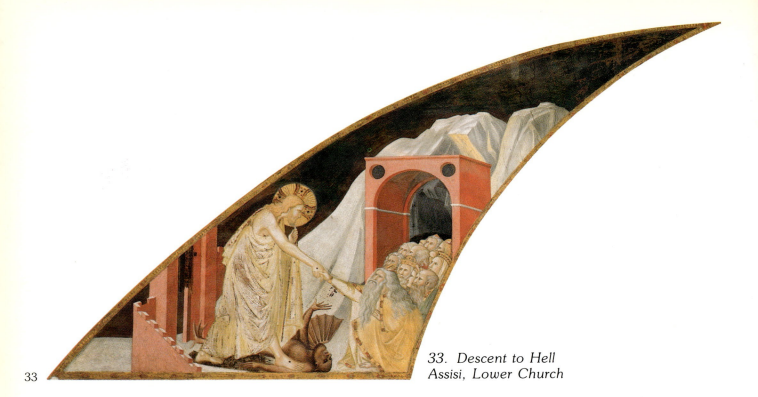

33

33. *Descent to Hell*
Assisi, Lower Church

shortly after the saint's death in view of his canonization (1228), the stigmatization is related to the fact that three times Francis opened his Bible, and each time it fell open at the Prologue to the Passion, which made him realize that his death would come after much pain and suffering. This interpretation is completely different from the one suggested by St Bonaventure, the only official biographer of Francis after 1266 (he even ordered that any source other than his *Legenda Maior* be destroyed). Bonaventure, in recounting the same episode as Thomas of Celano, writes that the Gospels opened in the middle of the Passion, thereby carrying the parallel between Christ and Francis to its logical conclusion, and presenting the saint as the "new Christ."

Lorenzetti has found a compromise between the two versions: on the one hand, the seraphin is no longer just an ordinary angel covered in wings and without a cross, as he had been portrayed about thirty years earlier by the Master of the St Francis stories in the same church; the wings are lowered, so that we can see Christ's wounded side through them; it is in fact Christ, nailed to the cross, who appears in the sky; his wounds like darts injure the saint in the same parts, on his hands, feet and side; only the wings, purely decorative, are still there as evidence of the earlier appearance of the angel. On the other hand, though, Francis, like Christ in the Garden of Gethsemane, is kneeling in prayer, amidst the rocks of La Verna mountain, but there are two olive trees here as well. In the Gospel according to Luke (22: 39-46) we are told that the pain that Christ felt, just imagining his future suffering, was such that it made him sweat blood (like Francis!), so much so that an angel (like the seraphin) appeared to him to give him strength. The other friar that Lorenzetti has painted is completely absorbed

in his reading and does not even notice the extraordinary apparition, for he is separated from Francis by a deep ravine; from an iconographical point of view he is analogous to the Apostles who cannot follow the Master either physically or spiritually, for they keep on falling asleep, at a distance from Christ who is totally immersed in prayer.

In the same transept, on the wall that leads to the Orsini Chapel, Lorenzetti painted Francis again, but this time as part of a devotional image: in the middle is the Madonna and Child, with Francis to her right 36 and John the Baptist to her left. The Baptist holds a scroll with the inscription (John, 1:23): *ecce vox clamantis in deserto, parate viam Domini* (I am the voice of one crying in the wilderness, Make straight the way of the Lord). The two saints, who are portrayed, like the Madonna, in half length looking out over a balustrade, are pointing downwards towards something that the onlooker cannot see, but can well understand. Both are in fact indicating the path they have come to prepare; this is confirmed by the grave look they exchange and the stigmatized bleeding hand that Francis raises, as the equivalent of the Baptist's scroll. Francis, too, spent all his life preaching the coming of Christ and his sacrifice, to the extent that he suffered the same pains; and it is to him that the Virgin turns her eyes, while holding in her arms her Son, still a child.

Below the huge Crucifixion we talked of earlier we see Francis again, looking out over the balustrade of a fake altar together with the Madonna and Child and 37 St John the Evangelist, this time in an open space, with no frames or decorations. Mary, looking at the Christ Child, makes the usual Lorenzetti gesture of indicating with her thumb backwards, in the direction of St Francis, who raises his stigmatized hand to his

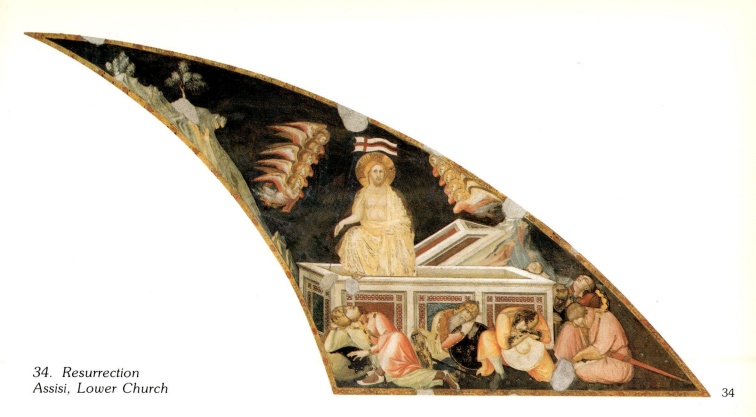

*34. Resurrection
Assisi, Lower Church*

breast to show that he accepts the calling. On the other side John, with the book of his Gospel in his hand, makes a gesture of assent. Here, too, the two saints gaze at each other intently. Of the two, Francis is definitely the privileged one: the stigmata are equated to the Scriptures and the true evangelical message is entrusted not to the sacred texts but to the real imitation of Christ, who appears, crucified and alone, im-

mediately underneath the Virgin. Perhaps Francis's right hand (now lost) indicated the devout painting below, which has also been lost; this is suggested by the presence on the other side of the fresco of a man kneeling devoutly in prayer, perhaps the person who commissioned the work. Lorenzetti has thus created a very strong relationship between the two Crucifixions: the first, monumental, takes place in a past that is very

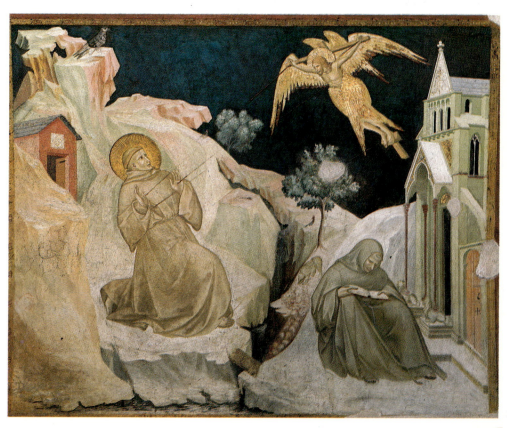

*35. Stigmatization of
St Francis
Assisi, Lower Church*

35

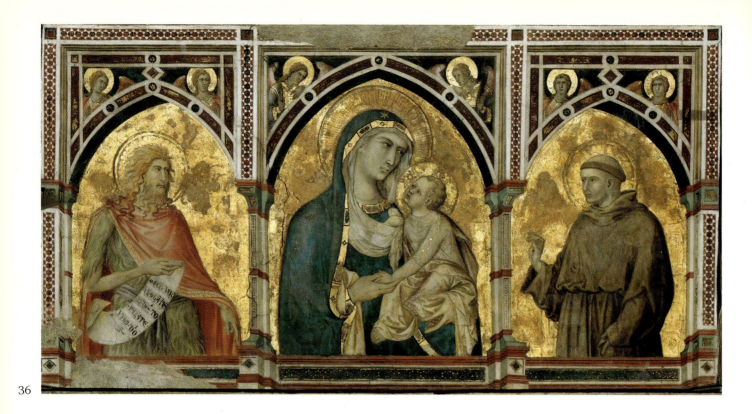

36

remote, while the second is brought closer to the age of the onlooker and made more relevant and meaningful precisely because of the presence of Francis, the living symbol of Christ's sacrifice and the man who dedicated his entire life to making the memory of that sacrifice relive in the hearts of men.

We cannot end our study of Lorenzetti's work at Assisi without at least mentioning the strange image that is painted on the end wall, below Saints Rufino, Catherine of Alexandria, Clare and Margaret, at the
38 foot of the wall: it is a *trompe l'oeil* bench, empty, placed against the wall, with a soft fur spread over it. But this is not the only *trompe l'oeil*, for in the lower part of the fake altar from which Francis, the Madonna and Child, and John the Evangelist appear to be looking out, there is a little painted niche containing a book and a mass-cruet. The *trompe l'oeil* is below a real wall cupboard, which must have contained the objects that have been painted in below. Since the bench is painted on the wall adjacent, it seems likely that the niche, the pew and the fake altar were probably intended to be seen as a fake chapel. A 19th-century photograph makes it easier to understand Lorenzetti's intentions, for it shows a real altar right next to the painted altar, giving a more concrete impression of a chapel: we must bear in mind that the Orsini Chapel is in the end wall of this side of the transept. Lorenzetti thus multiplies his spaces, suggesting the idea of another chapel, consecrated presumably to the devout figure or figures portrayed in the fake altar: an extraordinary invention, that no artist was able to match for a long time thereafter.

Around 1336-37 Pietro moved to Siena where, together with his brother, he painted a cycle of frescoes in the Chapter Hall of the monastery of San

36. Madonna and Child with St Francis and St John the Baptist
Assisi, Lower Church

37. Madonna and Child with St Francis and St John the Evangelist
Assisi, Lower Church

38. The Empty Bench
Assisi, Lower Church

Francesco (Ambrogio also painted a cycle in the cloister, but it has been destroyed). The date of these frescoes has been established thanks to the recent discovery by Max Seidel of two painted coats-of-arms above the door leading from the cloister to the Petroni Chapel (later called Martinozzi); they are dated 1336 and are part of the cycle designed by the two brothers. The fact that the cycle is to be considered a unit is proved by the same ornamental frieze which recurs throughout. Of the work done by Pietro the scenes that have survived are a Crucifixion detached from the 39 wall in 1857 and placed in one of the church's 26 chapels, which is very similar to the Crucifixion in Assisi, and a splendid Resurrection, at present on loan to 41 the Pinacoteca in Siena. In this painting Pietro has organized the composition in a completely different way, dividing the onlookers into two groups according to their degree of sainthood. Thus, at the left, we have the group of the Holy Women crowding around the Virgin who is about to faint and the desperate John; while to the right is the crowd of Romans and Jews, 40 and two figures among them, standing near the cross, have hexagonal haloes: the centurion and Longinus, with the same doubling of the character of Longinus

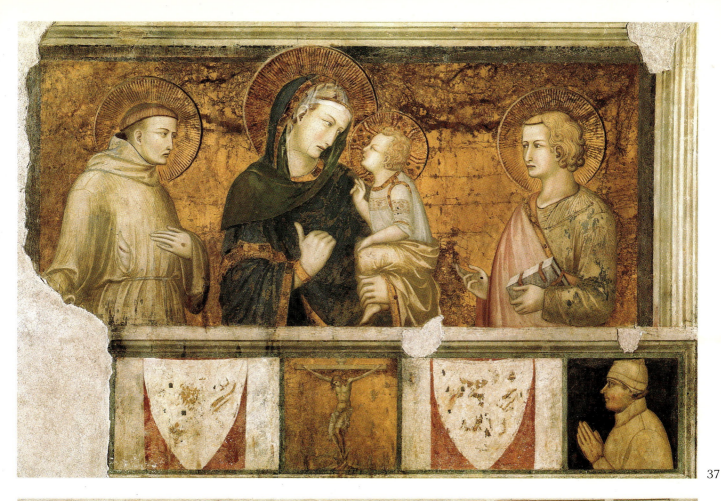

37

38

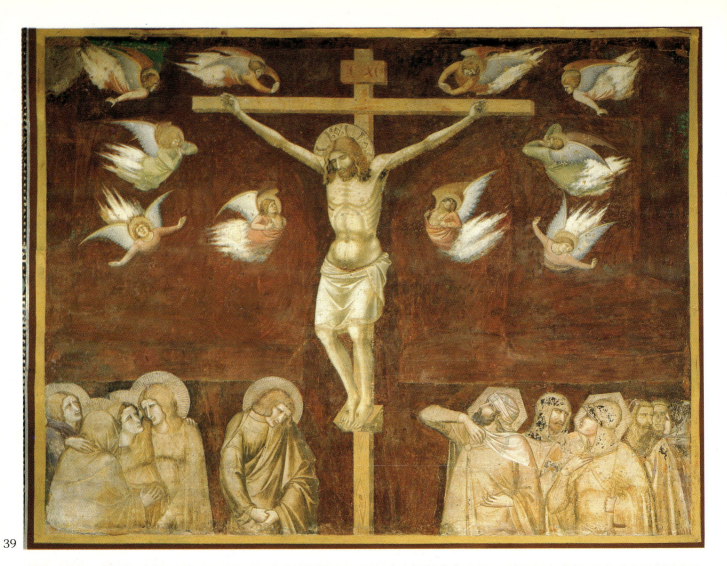

39

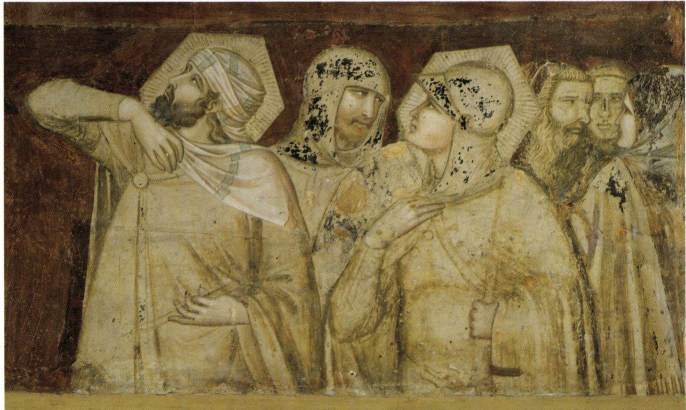

40

39. Crucifixion
Siena, San Francesco

40. Crucifixion,
detail of the centurion and Longinus
Siena, San Francesco

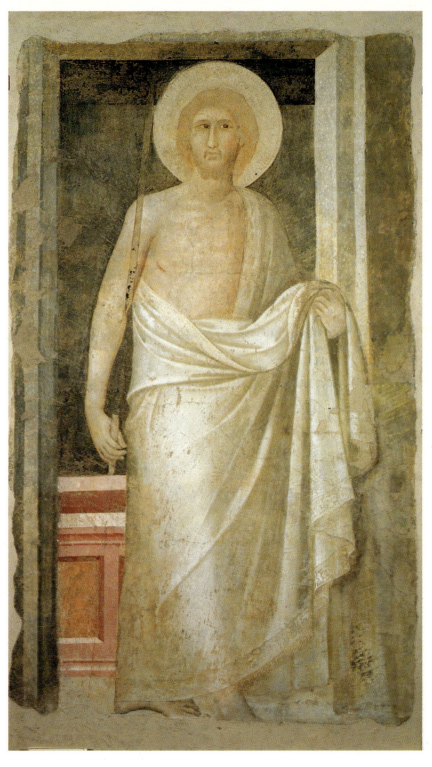

41. Resurrection of the Saviour
Siena, Pinacoteca Nazionale

41

that Pietro had already carried out in Assisi. The hexagonal halo, the same halo that we freqently find above the heads of the Virtues, indicates the goodness of the character, but it is one degree lower on the scale of sainthood (haloes with rays are the attributes of the blessed, normal round ones are those of saints). In other words, Pietro portrays these men as being miraculously converted, but not sanctified yet. The splendid gesture of the man bringing his hand to his breast implies the sudden recognition that the crucified man is Christ.

The other fragment from this cycle of frescoes illustrates, as we said earlier, the Resurrection of the 41 Saviour. The innovation here, as Enzo Carli pointed out, is that Christ is seen in front of the empty tomb. Lorenzetti spent a great deal of time in the study of classical statues, as can readily be seen from this standing figure, with his powerful bare chest, dressed like an ancient Roman, with his winding-sheet worn like a toga. But notice also the elegant flowing of the folds, clearly influenced by the work of Duccio, and "the pure profile, almost like a painting on a vase, which descends from the neck down to the right hand holding the slim rod of the flag."

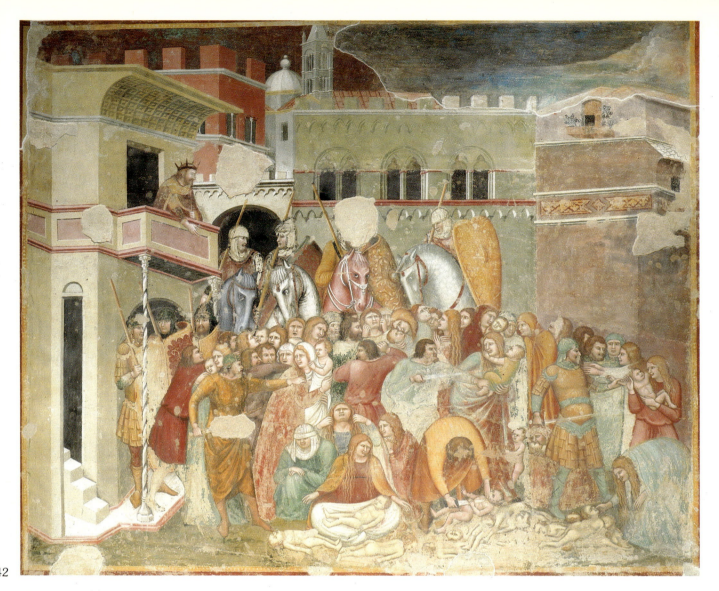

42

Of the cycle of frescoes in the church of San
42 Clemente ai Servi in Siena, only the Slaughter of the
Innocents, in the second chapel to the right of the
choir, can be said to be the work of Pietro. In it we find
the same dramatic force as in the Assisi frescoes: the
desperate mothers, for example, are reminiscent of
the grieving Mary Magdalene in Assisi, or the group of
knights exchanging glances from atop their restless
horses.

After this nothing more is known of Pietro Lorenzet-
ti: he was probably killed in the terrible plague of
1348, like his brother Ambrogio, who however has
left us an anguished testament.

42. Slaughter of the Innocents
Siena, San Clemente ai Servi

43-45. Stories from the Life of the
Blessed Humilitas
cm. 128 x 185
Florence, Uffizi

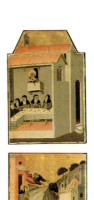

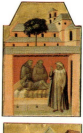

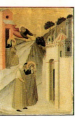

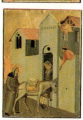

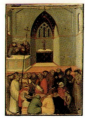

43

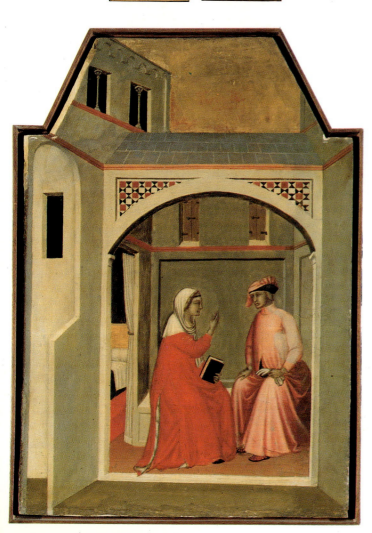

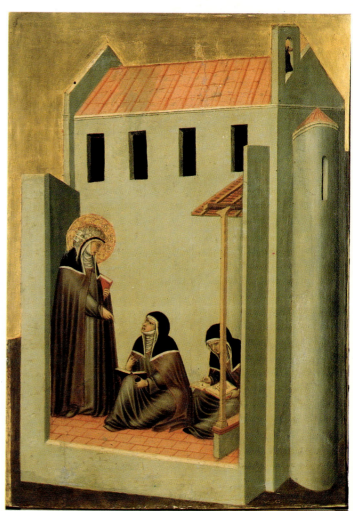

35

45

Ambrogio Lorenzetti: Biographical Notes

We have very little information concerning the life of Ambrogio, as is the case with his brother Pietro: his date of birth is unknown, although he was presumably born in the 1290s, since his Madonna from Vico L'Abate, the first dated painting that documents the artist's activity, was painted in 1319. We then find his name mentioned in the occasional document, in some payment registers; only two other paintings of his are dated, the Presentation in the Temple (1342) and the Annunciation (1344). Shortly before dying, however, he drew up a testament: this was found recently. It was written by him personally, on 9 June 1348, and in it he tries to arrange for the disposal of his property, foreseeing that very soon he will die, along with his wife and three daughters, the entire family killed by the Black Death of 1348. And that is obviously what happened, since the Company of the Virgin Mary, to whom he had left all his belongings in case none of the family survived, in 1348 and 1349 is recorded as selling some of his properties.

In order correctly to assess the greatness of Lorenzetti, we must bear in mind that unfortunately some vast cycles of frescoes have been lost. It was on these works that Ghiberti, for example, founded his enthusiasm: "A most noble composer," is Ghiberti's judgment of his work in the cycle he frescoed in the cloister of the church of San Francesco and in the Chapter Hall of that monastery, as well as in the frescoes of stories from the life of St Catherine in the Chapter Hall of the church of Sant'Agostino, both in Siena. Only a few fragments of these two cycles survive today. And nothing survives of the paintings on the facade of the Hospital of Santa Maria della Scala in Siena. It is interesting to note that Ghiberti only spends one line of comment on the frescoes painted in the Palazzo Pubblico in Siena (which, today, are responsible almost entirely for Ambrogio's celebrity), while he gives us an analytical description of all those works which have not come down to us; yet another reason to regret our enormous loss and to admire his great talent, which can be appreciated despite these important losses.

Unlike his brother Pietro, who was influenced by Duccio and by Giotto, Ambrogio was inspired more by Byzantine painting and by classical Roman art in forming his own extremely personal and highly original pictorial language, through which he expressed the qualities of his speculative mind and his great intellectual curiosity. As George Rowley so correctly points out, Ambrogio tackled a series of problems that we are normally accustomed to think of as belonging to a later period, to the Renaissance: the problems of perspective and of the realistic and not conventional rendering of situations, studies of the nude, attention to the artistic language of classical antiquity, awareness and sensitivity to weather and seasons in his subjects, effort to grasp individual and characteristic features in the faces and gestures of figures. And Ghiberti, in fact, called him "a most unique master . . . a man of great genius. He was a most noble draughtsman, he was expert in the theories of that art" and, going against the opinion of those who thought that Simone Martini was a greater artist, he concluded "to me Ambrogio Lorenzetti seemed much better and far more learned than any of the others." It is easy to understand how Ghiberti, who had just completed his Doors of Paradise for the Florence Baptistry, was primarily interested in problems of composition within a narrative cycle; but it is precisely the other qualities that he praises in Ambrogio, those of a man of great culture and intellectual originality, that allow us to picture him also as an active creator or co-originator of the elaborate painting cycles, and not just the man who carried out compositions conceived by others. A painter, in other words, in whom intellectual qualities were equal to artistic talent.

The Madonnas

It was only in 1922 that Giovanni De Nicola discovered the earliest dated painting (1319) by Ambrogio Lorenzetti, formerly in the church of Sant'Angelo at Vico L'Abate near Florence, and now in the Cestello Archiepiscopal Museum in Florence.

46 This Madonna and Child immediately strikes one because of its unusual composition and appearance, so much so that some scholars have even suggested that perhaps Ambrogio was following his client's orders in imitating images from much earlier periods. This Madonna, portrayed in a rigidly frontal pose, is modelled on the Byzantine idea of the Virgin as the Throne of God; according to this model, however, the Child should be placed in front of the Madonna, also in a frontal position, and the Virgin should be barely touching him with her fingers. Lorenzetti, though, has softened this sense of detachment, and has placed the Child firmly in his mother's arms; and the Child is shown as a lively baby (notice his restless foot) looking at his mother with love and trust. In this painting we can already see one of the characteristic features of Ambrogio's work: his ability to convey the monumentality of the figures without making use of chiaroscuro, which carves the shapes, but rather using large patches of compact colour, delimited by a particularly sharp outline, which here stands out in the geometrical divisions of the throne. The overturned perspective of the throne, Carli points out, "appears to push the image forward and to impose it, with forceful grandeur, on the onlooker."

 The peaceful mood expressed by Ambrogio's figures is noticeable also in the three paintings originally in the church of the former convent of Santa Petronilla in Siena (originally it was the church of the Umiliati), which are now in the Siena Pinacoteca where they

47 have been recomposed into a triptych. Their provenance justifies the scroll held by the Child: *beati pauperes*, blessed be ye poor: for yours is the kingdom of God (Luke, 6:20). The Child lovingly has one arm around his mother's neck, while the Virgin holds her face next to the Child's, gazing at him with an intense and penetrating look. It is this look of Mary's, fully aware and in sorrow for she already knows of the Saviour's Passion and the grief that awaits them both, that is the entirely new and original feature of Ambrogio's paintings of the subject of the Madonna and Child; and he devotes a great deal of attention to this expression. The two saints at the sides, Mary Magdalene to the left and St Dorothea to the right, participate in this moment of deep intimacy with their calm gestures. In the Middle Ages there was a great deal of confusion between several different female characters and they were frequently blended into one person: one is the nameless woman sinner who spread ointment over Christ's feet in the house of the Pharisee and was pardoned precisely because of her great love

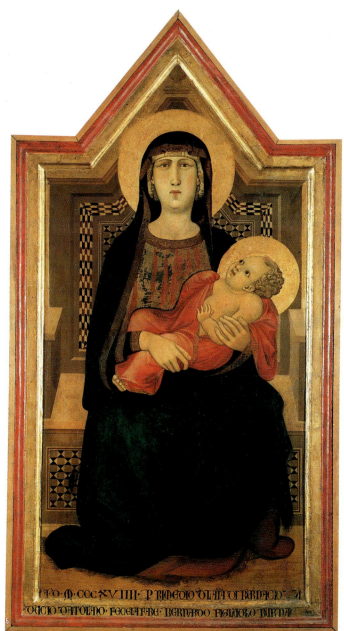

46. *Madonna and Child (of Vico L'Abate)*
cm. 148 x 78
Florence, Museo Arcivescovile del Cestello

for Christ, whose feet she had washed with her tears, and kissed and dried with her hair (Luke, 7: 36-46); another is Mary Magdalene, possessed by the evil spirits and healed by Christ (Luke, 8:2), who was the first to see him after the Resurrection (Mark, 16:9); and lastly, Mary of Bethany, the sister of Martha and Lazarus, who foresees the imminent death of Christ and pours a precious ointment on his head during the feast in Bethany (Matthew, 26: 6-13). Lorenzetti, too, blends together these different characters: Mary Magdalene holds in her hand a precious ointment pot and, because of her beauty and red dress, she is probably the blonde sinner Christ saw in the house of the Pharisee; but on her breast we see the bleeding face of the crucified Christ, which is the dramatic forebod-

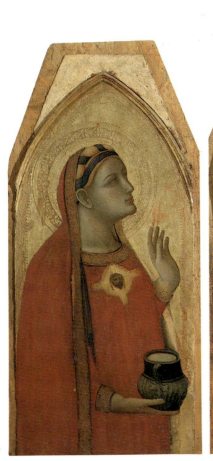
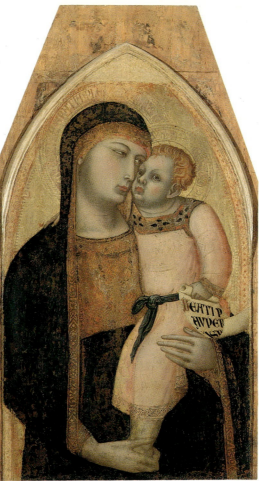
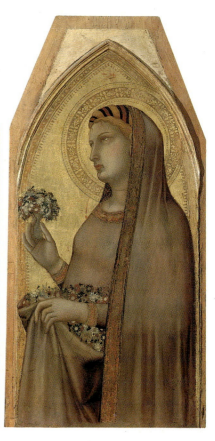

47

ing that Martha's sister had in Bethany, although it is placed on the heart, to symbolize, once again, the great love shown by the sinner. On the other side, St Dorothea, with her lap full of flowers, offers a bunch of flowers while looking at the Christ Child in a serious and intense way: this is a reference to the culminating moment of her story, when while she is being led off to her martyrdom she meets the unbelieving Theophilus, who asks her to send him flowers and fruit from the gardens of Paradise. The saint then concentrates in prayer and just before she is decapitated a child (the Christ Child) appears to her, bearing a basket of flowers and fruit which will succeed in converting Theophilus. In the triptych both the saints continue with the sorrowful meditations of the Virgin (on the halo we can read the words of the angel, *Ave Maria, gratia plena*, a reference to the Virgin's humble submission); Mary Magdalene shows the Man of Sorrows on her heart and the pot of ointment, in memory of the one she took to the already empty sepulchre; Dorothea, on the other hand, who is looking straight at Jesus, is showing him the bunch of flowers, the symbol of her martyrdom and of the gardens of Paradise where the Saviour is waiting for her. Christ's earthly life is recounted in the splendid predella containing the Lamentation over the Dead Christ.

This expression of total awareness is conveyed even more movingly in the embrace of Mother and Child in the painting that comes from the church of San Loren-zo at Serre di Rapolano (near Siena); it was probably part of a triptych and is now on exhibit in the Siena Pinacoteca. The Virgin holds the Child to her in a protective gesture and lowers her head so that she can touch his cheek with her own: her melancholy gaze is lost in space. The Child's arm is wrapped around her and grabs her veil from behind: his expression, too, is one of astonishment and bewilderment. In his hand he holds a robin, considered in the Middle Ages an omen of death because of its blood-red plumage. In the Maestà in the church of Sant'Agostino in Siena (which we shall deal with later) Jesus actually appears to be frightened and draws back from the little animal that the Virgin is offering him. 52

In the Madonna del Latte, too, now in the Archbishop's Palace in Siena (formerly in the Seminary of Lecceto), which is possibly one of Ambrogio's most popular paintings, motherly love is expressed as suffused with melancholy. 49

The Madonna is almost forcefully holding the Child in her arms for he is rather older than in the previous paintings, and he is heavy and restlessly kicking about, with an extremely realistic movement, pressing his foot against his mother's arm, who is forced to spread her fingers and hold on to him with strength to stop him from slipping away. Unlike the traditional early 14th-century altarpieces, here Mary is not placed in the centre: she has been moved slightly to the left so that the Child can be seen to be the true protagonist.

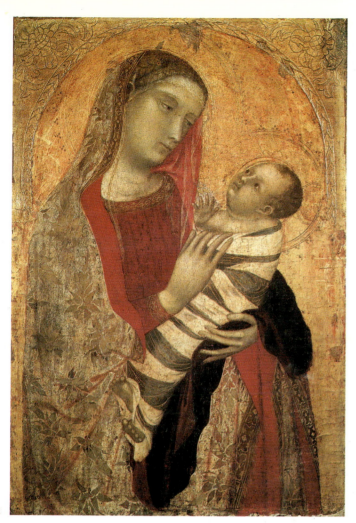

48

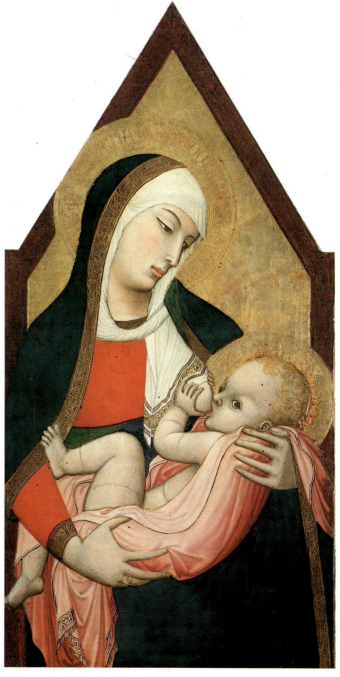

47. *Madonna and Child with Mary Magdalene
and St Dorothea*
cm. 90 x 53 (central panel)
cm. 88 x 39 (side panels)
Siena, Pinacoteca Nazionale

48. *Madonna and Child*
cm. 85 x 57
Milan, Pinacoteca di Brera

49. *Madonna del Latte*
cm. 90 x 48
Siena, Palazzo Arcivescovile

In this painting, too, the words of the angel of the Annunciation are inscribed on the Virgin's halo; her lowered and sorrowful face shows that she is aware of holding in her arms the Divine Son, contemplated through the Passion that awaits him. The Child is suckling with infantile greed, with his hands pressed against his mother's breast in a very realistic gesture; but his eyes are turned towards the onlooker and this detail is enough to convey a deeply devotional meaning, for it is as though the Christ Child had stopped suckling in order to listen to the prayers of the onlookers. This group achieves an extraordinary degree of monumentality, obtained by making the Virgin's body continue outside the frame (a purple ribbon also painted by Ambrogio) which, as Rowley suggests, seems to project the Madonna and Child in an illusionistic way towards the spectator. This is a totally original invention of Lorenzetti's, who thus gave a new interpretation to the old subject of the nursing Mother from the Byzantine tradition.

Since we have so few certain historical data, several other splendid Madonnas were in the past attributed to Ambrogio Lorenzetti and then later re-attributed to other artists. We shall therefore only deal with those paintings that scholars agree upon at present.

48 From the youthful (?) Madonna in the Brera in Milan, where the tightly swaddled Child succeeds in ex-

49

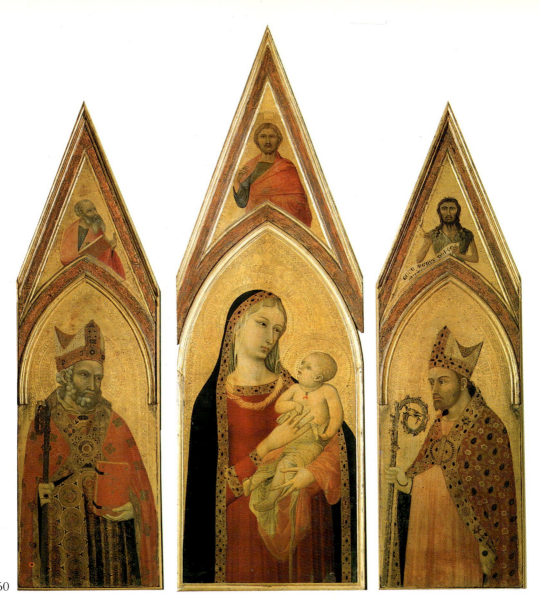

50

pressing his vitality by the movement of his feet and his hand outstretched towards his mother, Lorenzetti began to study the subject of motherly love, seen as protecting the tiny defenceless Child; this theme is continued in the Madonna, dating from about 1332, formerly in the Berenson Collection at Villa I Tatti in Settignano (near Florence). In this painting, the Virgin looks at the Child with an intense and anxious expression; Jesus holds the forefinger of her graceful and elegant hand as reassurance. This Madonna, together with the paintings of St Nicholas and St Proculus from the Bandini Museum in Fiesole, has now been reconstituted as a triptych in the Uffizi in Florence. Similar in many ways to this Madonna, is a Madonna and Child that is part of an altarpiece contained in a lavish 16th-century frame in the Museum in Asciano, where the Child is holding on to his mother's veil, not her finger. In the central panel we see an Archangel Michael full of movement, killing a dragon, and this figure can be used as an example of the incredible disparity of opinions between art historians: according to Rowley, this Archangel dates from the mid-15th century because of the marked Late Gothic style of the lines

50. Madonna and Child with St Nicholas and St Proculus
cm. 166 x 57 (central panel)
cm. 147 x 43; cm. 145 x 42 (side panels)
Florence, Uffizi

and the drawing, whereas in Carli's opinion it is "one of the most extraordinary creations of Trecento painting and, despite the hand of some assistant, it bears the unmistakable mark of Ambrogio."

The Maestà Paintings

In 1944 a very complex Maestà was discovered in the Piccolomini Chapel in the church of Sant'Agostino in Siena; it is the only surviving fresco of the cycle described with such admiration by Ghiberti. The subject of the frescoes was the exaltation of St Catherine of Alexandria, and more specifically of her dramatic meeting with the Emperor and her disputation with the pagan philosophers; these two scenes were separated by a Crucifixion. There is no scene of St Catherine's martyrdom, but in the Maestà she is portrayed in the act of offering her head on a gold plate, and this is iconographically very unusual. Ghiberti praised Ambrogio's remarkable ability to make crowds move, showing them as they progress naturally through buildings or in the open.

St Catherine's meeting with the Emperor has been lost, but we can get an idea of the compositional innovations from the fresco on the same subject that Andrea da Bologna painted in the Lower Church at Assisi, for he undoubtedly used Ambrogio's painting as his model. The scene is entirely portrayed from an angle, and there are large wooden pews used as elements of separation and communication at the same time: "It is as though there was a celebration that day in the temple (there are musicians and dancers), and there are great crowds both inside and out."

A recent study by Max Seidel has connected this cycle of frescoes in a very convincing way to the subjects of the Augustinian historiography of the time and to the problems being debated by the Order of Augustinian Hermits; and in 1338 the Order had held a meeting of its Chapter to discuss precisely these questions, in what is now the Piccolomini Chapel. We can therefore safely say that the frescoes were painted around this time, probably immediately after the Chapter meeting. Seidel also explains the presence of St Catherine and the logical coherence of the iconographical plan. Her story is to be related to the Crucifixion of Christ, because her disputation with the Emperor was on the subject of the *misterium crucis*, or mystery of the cross; Catherine attempted to convince the pagan philosophers, with learned quotations from the Scriptures, of the truthfulness of Christ's Passion. This connection is repeated in the Maestà which we are about to look at; here, the martyred saint offers her own severed head to the Child, who draws back in terror from the little robin that his mother is showing him. In the centre of the painting there is the Virgin, whose melancholy expression is turned towards the spectator. The throne, and this is a truly daring innovation, consists in the spread wings of the seraphim, indicating that the Madonna is no longer on earth. A group of saints, each with his own attribute. is addressing the Virgin; but four of them are saints who appear very rarely in paintings and some of the others are difficult to identify with certainty, so that we cannot offer an acceptable overall explanation.

Seidel's recent study, which has certainly increased our understanding of this complex work, unfortunately only deals with some sections of the painting, not mentioning others.

To the left we see St Agatha offering her amputated breasts and St Catherine with her severed head; behind them is St Augustine carrying three books and St Bartholomew with the knife used to flay his skin. To the right, a female saint whose identity is uncertain and St Apollonia, wielding an enormous pair of pliers with a tooth in it, a symbol of the torture she was subjected to (all her teeth were torn out). Behind, a very old monk and the Archangel Michael.

In his analysis of St Catherine, Seidel quotes a passage from her *Passio*, when the saint declares that it is her intention "to offer my flesh and my blood, as Christ offered himself for me in sacrifice to God the Father." This justifies, in my opinion, the presence of those saints with the gruesome attributes of their horrific tortures (Agatha, Apollonia, Bartholomew). Catherine also wears a ring, a symbol of her mystic marriage to Christ, which she recounts in her *Passio*: "I was wedded to Christ with an indissoluble tie, to him, my glory, my love, my sweetness, my beloved." And it is this detail, which stresses the love that is the foundation for Catherine's faith, that is paralleled perfectly in the attribute carried by the saint placed symmetrically on the other side of the throne: she bears, in fact, a vessel from which emerges a pulsating and fiery little cherub. I do not think that this is St Clare as Rowley suggests; Clare stopped the Saracens with a monstrance, and in the polyptych by Giovanni di Paolo in the Siena Pinacoteca she holds a vessel with a cherub in her hand, but she is portrayed, as usual, in a nun's habit, while here she has a lavish red dress, with a wide red cloak covering her head, through which we can see her elegantly coiffed blonde hair; and furthermore the transparent veil around her chin clearly indicates that she is not a virgin. Nor do I agree with Seidel, who attempts to relate the light cast by the seraphim to the etymology of the name of St Lucy, because this would not explain the vessel and also because Lucy, too, is a virgin saint. I am of the opinion that she is to be identified as Mary Magdalene, bearing in mind, as we said earlier, that in the Middle Ages several different stories of different women were all attributed to this one saint. The blonde hair, the red dress and the wimple all fit perfectly with the iconography of Mary Magdalene, a sinner redeemed by her love for Christ. This love is symbolized by the gesture of pressing her hand to her breast and by the pulsating seraphim, also a symbol of deep love; the vessel of ointment is a reference to the precious ointments with which she anointed Christ, for she predicted his imminent death and was overcome by love for him. In the polyptych now in the Siena Pinacoteca, which we spoke of earlier, Mary Magdalene, also blonde, dressed

41

51

in red and bearing an ointment jar, has the face of Christ covered in blood painted on her breast within a shining halo, again a reference to this same combination of love and prediction of the Passion. And furthermore, among the saints of a dismembered polyptych now in the Siena Museo dell'Opera del Duomo, Ambrogio has included St Francis with the stigmata: above his chest wound there is a fiery seraphin, which almost appears to suggest that the wound was actually caused by Francis's great love, for he meditated on Christ's Passion (or rather, as Thomas of Celano says in his *First Legend*, on the passage that deals with Christ's future Passion). Mary Magdalene, therefore, like St Catherine, recalls the great love that binds them to Christ, experienced in different ways, either through wisdom or emotional impetus, in the sufferings of the imminent Passion. St Augustine, the saint to whom the church is consecrated, also holds an unusual attribute and his garments are not those in which he is normally portrayed, for he is dressed like a bishop (and even has a mitre) but underneath is wearing the black habit of the Hermits. Quite rightly Seidel points out that this fresco is the earliest evidence of a new historical conscience of the Hermits of St Augustine, who consider Augustine himself the founder of their Order, in contrast and disagreement with other Orders, who also follow the Augustinian Rule but consider him merely a leader *ex devotione* and not *ex institutione*. The three books that Augustine is carrying in this painting refer to an issue that was debated at the meeting of the Chapter General in 1338: that Augustine had written a Rule for the Hermits and the Canonicals, and two further ones solely for the Augustinian Hermits. The old bearded monk, on the other side of the throne, according to Seidel's theory is either St Anthony Abbot, considered one of the *primarii funda-*

53

tores of the Order together with Paul, or William of Malavalle, a hermit who lived a very austere life and died in 1157. In my opinion, however, this attribute is equally justifiable for St Anthony Abbot, who lived in the desert. For St Anthony seems to me to fit in better with the propagandistic intentions of the painting, all the more so since Henry of Friemar, in the treatise that deals with the origins and the development of the Hermit monks and with their real title, in 1334 had established that Augustine's work had been carried on by Anthony, "the primary founder of the Order," using the metaphor of the root whose virtue naturally produces luxuriant branches.

The presence of St Catherine, who was also praised at the meeting of the Chapter in 1338 by Jordan of Saxony for having succeeded in harmonizing human and divine knowledge, is totally in line with the decision made at that meeting to devote greater energies to scholarship; the monastery and church of Sant'Agostino since 1315 had housed a *Studium Generale* and a large library, which expanded very rapidly as we learn from the catalogue of its contents drawn up in 1360. The unusual representation of the Creed on the ceiling of this room is a confirmation of the new desire to pursue learning and knowledge that the Order had so clearly expressed. What is still unexplained, at present, is why the Archangel Michael (allusion to St Galgano?) was placed among the other saints; Seidel's explanation, that he is portrayed because his image was carved on a reliquary belonging to this church, is certainly not a sufficient answer.

Equally mysterious, at least in some respects, is the complex Maestà painted in the Monte Siepi Chapel, a few hundred yards from the Abbey of San Galgano, in the countryside near Siena. Thanks to a document that was discovered recently by Alison Luchs, we

54

52

51. Maestà
Siena, Sant'Agostino

52. Maestà, detail
Siena, Sant'Agostino

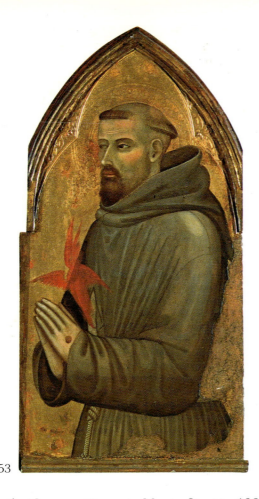

53

know that Lorenzetti was in Monte Siepi in 1334, and this information was confirmed by the lost inscription (which we know of because it was recorded in 1645) in the chapel: "This painting and the chapel were commissioned by Ristoro da Selvatella, 1336." The walls of the chapel are covered with frescoes in extremely bad condition illustrating the life of St Galgano. Even the lunette containing the Lorenzetti Maestà has suffered alterations and been painted over in parts; the Annunciation below it was entirely repainted. During the 1966 restoration work, the sinopias under the frescoes were brought to light, and they allow us to admire at least the compositional innovations of Lorenzetti's work. In the Maestà the Madonna with the Child is placed on a throne with steps, which rests on a platform with more steps leading up to it; alongside the steps there is a group of saints. At the Virgin's feet, in striking contrast, there is the stretched out figure of Eve, wearing a white dress (her pose recalls the later figure of Peace in the Palazzo Pubblico frescoes), with a goatskin over her shoulders, a figtree branch in one hand and a scroll in the other, unfortunately both very clumsily retouched during attempts at restoration. The text, as it appears at present, is: FEI PECCHATO P(ER) CHE PASSIO/NE SOFERSE XNO CHE QUES/TA REHA SORTE NEL VENTRE / A MOSTRA REDENTIONE which, interpreting the abbreviations in use at that time, is probably to read as FEI PECCHATO P(ER) CHE PASSIO/NE SOFERSE CRISTO CHE QUES/TA REINA PORTO' NEL VENTRE / A NOSTRA REDENTIONE (I committed

55
85

the sin for which Christ, whom this queen bore in her womb, suffered the Passion for our Salvation).

The title of queen attributed to the Virgin is probably a reference to the original version of the fresco which, as we learnt from the restorations, showed the Madonna wearing a crown and bearing in her gloved hands a sceptre in the left, and the orb in the right instead of the Child. This extremely unusual, and rather daring, iconography was eliminated shortly after the completion of the fresco and replaced with what we see at present, a much more traditional form. The only other time that Lorenzetti was this daring was in the Maestà (which, unfortunately, is all but destroyed) that he painted in the Siena Palazzo Pubblico, where the Madonna, seated on the throne, holds the Child in her right hand and an orb in her left; but the orb is black and white, the colours of the city of Siena, and the Christ Child is directly blessing it with one hand, while in the other he holds a scroll inscribed with a verse from John (13:34): *scribe mandatum novum do vobis ut diligatis invicem* (A new commandment I give unto you, That ye love one another). According to the medieval chronicler Agnolo di Tura, who dates this fresco at 1340, at the feet of the Virgin Lorenzetti had painted the Cardinal Virtues, arranged so as to form a sort of predella, rather like the Theological Virtues that form an ideal predella of the Massa Marittima 57
Maestà. The Siena Madonna was painted after the frescoes of the Good Government, in which the Com- 83
mune (or the Common Good) is portrayed seated on his throne and assisted in his work by all seven Virtues, and also after the "Cosmography" mentioned by Ghiberti, the *mappamondus volubilis* (or revolving globe) which Lorenzetti painted for the Main Hall of the same Palazzo Pubblico, to this day still called Sala del Mappamondo (in which, however, according to Sigismondo Tizio the artist had illustrated all Siena's territorial possessions). It is therefore quite understandable that a painting of the Virgin holding an orb which was in fact a representation of Siena was tolerated in this Palazzo Pubblico; the orb is presented not as a majestic attribute of the Madonna, but rather as a symbol of the protection she granted to the city (it is basically after the battle of Montaperti that the Virgin becomes the patron of Siena); it is also blessed by the Christ Child.

In Monte Siepi, on the other hand, the Madonna 54
was portrayed as a queen, bearing the symbols of an entirely human power (and one usually held by males), and without the Child although it is the extraordinary nature of her motherhood that is normally taken as the main aspect of her sanctity. We can therefore easily understand why this innovation did not meet with the client's approval. On the same wall, Lorenzetti had attempted another iconographical innovation, painting the Virgin Mary as being discon- 56
certed by the arrival of the Angel and by his announcement to her; she reaches out for a column and holds on to it, as though she needed steadying. All of this is visible in the sinopia, whereas the fresco on the wall now simply shows an Annunciation according to

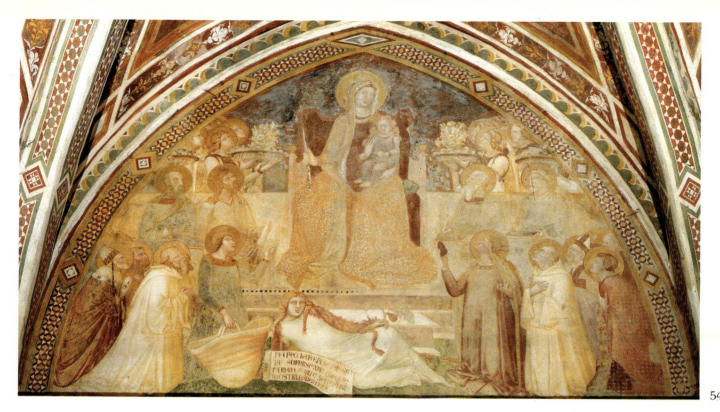

54

53. *St Francis*
cm. 110 x 44
Siena, Museo dell'Opera del Duomo

54. *Maestà,*
San Galgano, Monte Siepi Chapel

the usual model, with the Madonna, her arms humbly crossed, accepting the Angel's message.

Let us return to the Maestà and the unusual figure of the blonde Eve. The goatskin covering her shoulders (we know it is goat because of the little cleft hoof that hangs across the figure's stomach, and which has always been interpreted as a snake, in fact *the* snake) has a twofold meaning: on the one hand, it is a reminder that Eve only gave birth after having sinned, after having felt shame and the need to cover her body, and this is echoed also by the figtree branch Eve bears in her hand. (*Eva in paradiso virgo fuit: post pelliceas tunicas iniptio sumpsit nuptiarum. . . virginitatem esse naturae, nuptias post delictum* in the words of St Jerome: All the while she was in Paradise, Eve remained a virgin; her marriage took place after she began to cover herself with animal skins. . . Virginity is a natural state, marriage is a consequence of sin). On the other hand, the reason why the animal skin is a goatskin, is that in the Middle Ages the goat was the traditional symbol of lust.

At the sides of the throne, to the left and the right of Eve, there are two female figures of a very unusual appearance; one carries an enormous straw basket from which she pulls out a bunch of fruit and flowers, while the other has a flaming crown on her blonde hair and is offering a heart. In order to understand their meaning we must make a short detour, and briefly look at the treatise by Robert Freyan on the changing idea and representation of Charity in the 13th and 14th centuries. Already in the writings of St Augustine

this Virtue had a twofold nature, since she was both *amor Dei* and *amor proximi* (the love of God and the love of one's neighbour). Precisely because Charity had this human aspect, she was soon combined with the portrayal of Mercy. And as such we see her coming to the aid of the six poor people who are hungry, thirsty, naked, imprisoned, travellers or sick, in the representations of the Acts of Mercy on the Hildesheim baptismal font of the 12th century (the burial of the dead, as the seventh act of mercy, was only added to the others in the 13th century). In one of his sermons, Innocent III interprets the transformation of water into wine at the wedding at Cana as the transformation of the Virtue of Mercy into the Virtue of Charity. As a result Charity gains the attributes of the cornucopia, or horn of plenty, full of fruit and flowers and a child whom she feeds (a misunderstanding of the naked man she clothes). From this point of view she is above all Charity-Mercy, love of one's neighbour. But Charity is also *incendium amoris* (the fire of love) which, according to St Bonaventure's expression pushes man towards God. This spiritual love is extraordinarily close to human love, and actually, according to the penetrating observation made by St Bernard, "there shall never be charity without desire, for we are men born of the flesh." It therefore becomes understandable how the iconography of profane love, seen as a flame that sets the heart alight (just to quote Ovid), interfered in the formation of the iconography of Charity as *amor Dei*. In a song attributed to St Francis, one verse reads: *Amor di caritate / perché m'hai si ferito?*

45

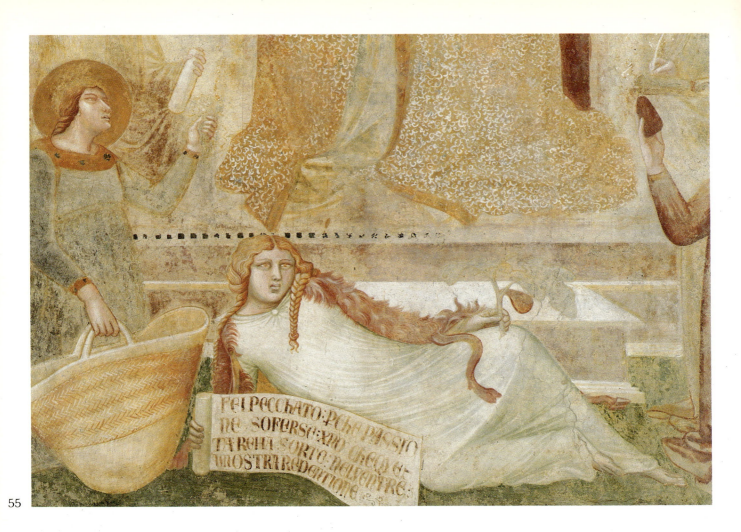

55

lo tutt'ho partito / et arde per amore (Love of Charity, why have you wounded me thus? My heart is all broken and it burns with love). In the pulpit of Siena Cathedral Nicola Pisano portrays Charity with a horn of plenty which ends in the shape of a goat's head, with a huge flame coming out of it: a symbol, according to the ideas of St Bernard, of the passage from earthly to spiritual love, to the love of God. In the figure of Charity in the Scrovegni Chapel in Padua, Giotto has illustrated the various aspects of this Virtue, for he shows her in her merciful role as she offers fruit and flowers standing on a pile of open bales of wheat, and in her aspect of more spiritual love, as *amor Dei*, offering a heart; and, in fact, Baldwin of Ford in his treatise *De dilectione Dei* writes, "if truly you shall offer your heart unto God, by giving it to God you shall make it your own."

If we now return to our fresco in Monte Siepi, it will be clear that the women are to be interpreted as the two aspects of Charity, *amor proximi* to the left and *amor Dei* to the right. (We must also bear in mind that Tino da Camaino had sculpted a Charity with a flaming crown for the church of San Lorenzo in Naples, but with the addition of two putti.) If we think back for a minute to the fresco as it was originally conceived, that is when the Virgin was still shown as queen, we realize that Eve with her figtree branch and her scroll, the Madonna and the two figures of Charity, with two angels above them bearing two large baskets of fruit and flowers, can be interpreted as the visualization of a prayer, the *Salve Regina*, which was written in the 12th century. The Virgin, whose help is invoked as an intermediary between God and men, is called the *Mater Misericordiae* (Mother of Mercy): the prayer begs her to turn her merciful eyes towards mankind, towards the exiled children of Eve and to show *fructum ventris tui* (the fruit of your womb).

The figure of Eve, stretched out so languidly, is a reference to the dawn of humanity, marked by sin symbolized by the fruit of the evil tree, the figtree, which she is showing (after the first sin, mankind uses figleaves to cover its nakedness, but the figtree is also the tree that was cursed by Christ, and the tree from which Judas hanged himself, at least according to a traditional legend). The New Eve is the Virgin, and the fruit of her womb is blessed (the pun on the words *Eva* and *Ave*, the first word pronounced by the Angel of the Annunciation, was common at the time). The scroll in Eve's hand also refers to the Virgin as queen, bearing Christ in her womb; this allows us to understand why Mary is portrayed without the Child, as a queen with the orb in her hand, the equivalent of the vale of tears mentioned in the prayer.

The fresco below is a further development of the subject of the scroll Eve is holding: it shows the Annunciation, that is the moment of the Incarnation. Precisely because she is *Advocata Nostra* and *Mater Misericordiae*, the Virgin can be portrayed with both

46

56

aspects of Charity at her feet. But we might also attempt a more circular reading, seeing Eve and the two female figures as the gradual transition of love from carnal lust to love that is sublimated in the love of God, as St Bernard believed; and Bernard may well be one of the two Cistercian monks, probably the one to the right, the one that the figure of Charity with the fiery crown is pointing towards. This would also be justified by the fact that it was St Bernard, in his commentary to the Song of Songs, who first proposed the anagramme Ave/Eva and who used the metaphor of the Virgin's womb flowering like the rod from Jesse's tree, and who, in a sermon on the Annunciation, spoke of Charity, Mercy and Peace as the "Advocates" of the human race.

This unusual Maestà has been included in the story of St Galgano because it was at the top of the hill of Monte Siepi, guided by Archangel Michael, "that he had his second vision of the Son of God and of the Queen of the Angels: the mother of God surrounded by the twelve Apostles, seated on a large and majestic throne." Ambrogio and his client chose to portray only Peter, Paul and the two Johns (this choice lends credibility also to another document, the testament of Vanni, or Giovanni, di Messer Toso dei Salimbeni, dated 1340, who wanted a chapel to be built near the Abbey of San Galgano and for it to be decorated with frescoes). The other eight Apostles described in the vision have been replaced by a pope (possibly Lucius III, the pope who canonized St Galgano), two Cistercian monks and other monks: for all of them identifications have been proposed with local saints and blessed, but there is no certainty for any one of them. It is in any case clear that Ambrogio did not hesitate to give St Galgano's vision a mood of local colour; even the iconography of the Annunciation, which is based on the text of the Apocryphal Gospel called Pseudo Matthew, is drawn from a story that circulated in Siena at the time; we know of it from Niccolò da Poggibonsi, among others, from his diary of a journey to the Holy Land in 1346, in which he wrote that "at Nazareth one can still see Our Lady's chamber: in it there is the column that Holy Mary embraced, out of fear, when the Angel announced his message. . . above the column there is a large window, through which the Angel entered for the Annunciation." In Monte Siepi, the scene of the Annunciation is divided into two by a real window, the one that lights the chapel; once again we can but admire Ambrogio's ability to make use of the surroundings, incorporating them with great naturalness into the narrative.

The Massa Marittima Maestà

Around the same period (it is usually dated at about 1335), Lorenzetti painted a large Maestà in Massa 57 Marittima, mentioned by Ghiberti. The painting, divided into five separate sections, was discovered in 1867 in the monastery of Sant'Agostino in that town, stored away in an attic; it was transferred to the Town Hall, where it still hangs today. (The Theological Virtues seated at the foot of the throne are very strongly reminiscent of some of the personifications in the Good Government frescoes, and may therefore indicate a later date for this painting).

The composition of this Maestà is truly monumental: the Virgin sits on a throne atop three steps, each one painted the same colour as the Theological Virtue seated on it. The name of the Virtue also inscribed on the step: on the lower one is *Fides* (Faith), dressed in white, looking into a mirror where she sees the figures of the Trinity (the dove has almost entirely disappeared); on the second we find the green *Spes* (Hope), with a crown and lilies; on the third, *Caritas* with her fiery costume, bearing in her hands a heart and an arrow. Six musician angels carrying thuribles kneel at the foot of the throne, around which are crowded another four angels, two of whom uphold the Virgin's cushion and form the cusps of the throne with their wings (just like in the Maestà of Sant'Agostino), and two are casting flowers over the Madonna and Child. The rest of the composition is taken up by a numerous crowd of patriarchs, prophets and saints, among whom we can make out St Cerbone with his geese, the patron saint of the city of Massa Marittima. The multitude of haloes is so crowded that it is difficult even to distinguish the faces: a device borrowed from

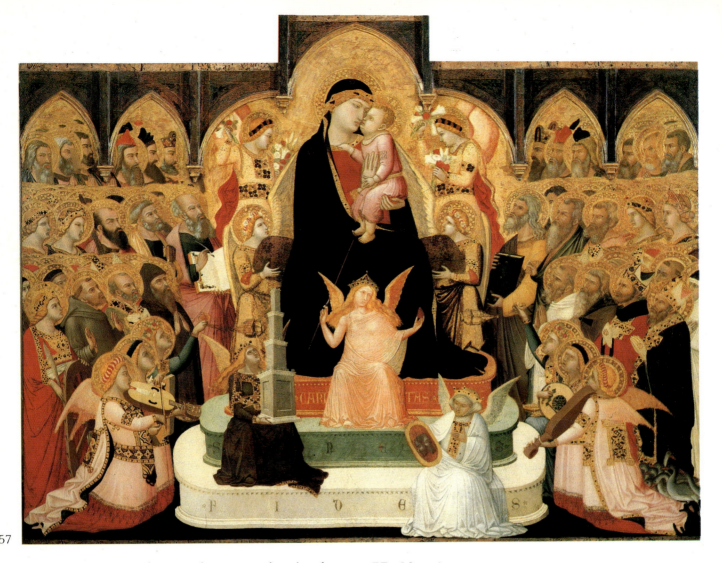

57

Byzantine iconography to indicate a multitude of witnesses. The scene takes place somewhere which is both earthly and heavenly. The musician angels, in their various functions, suggest Paradise: the idea is rather reminiscent of Dante's vision of Beatrice, dressed in the three colours of the Theological Virtues, when she appears to him in Canto XXX of Purgatory, "through cloud on cloud of flowers Flung from angelic hands and falling down Over the car and all around in showers." Whereas the all too human embrace of the Virgin bending her face close to her Child's, almost as though she were about to kiss him, is entirely earthly. Her expression is unforgettable, an expression of sweet sorrow, while the Child clings to her, seeking protection, that protection which the mother will not be able to offer against the future suffering of the Passion. The three Theological Virtues mark the transition from earth to heaven; according to Petrus Cantor's definition, Faith lays the foundations of the spiritual edifice, Hope builds it and Charity crowns it.

In this part of the painting, too, where there is a preponderance of theological interpretation and of allegorical elements, Ambrogio does not forget human reality: and Charity is portrayed in a transparent gown of classical style (unlike the other two Virtues who are dressed in medieval costumes), and carries an arrow

57. Maestà
cm. 155 x 206
Massa Marittima, Palazzo Comunale

58. The "Little" Maestà
cm. 50 x 34
Siena, Pinacoteca Nazionale

in her hand as well as a heart: both the nudity and the arrow are an allusion to Venus, to the earthly aspect of love. Undoubtedly Ambrogio's intention is to portray Charity according to St Bernard's interpretation, which connects Charity to Lust, even though the attribute of the heart is a reference to the love of God; as Gilbert of Hoyland writes, "The power of Charity is great and violent, and reaches all the way to the love of God, penetrates it and, like an arrow, pierces his heart. . . God Himself has encountered the wound of violent love." Ambrogio succeeds in combining, with great mastery, the ideas of adoration, of doctrinal meditation and of strong emotional feelings, in order to offer the spectator a painting in which the devotion of the faithful might move through the illustration of concepts and symbols to reach the sphere of the most intense and profound emotions.

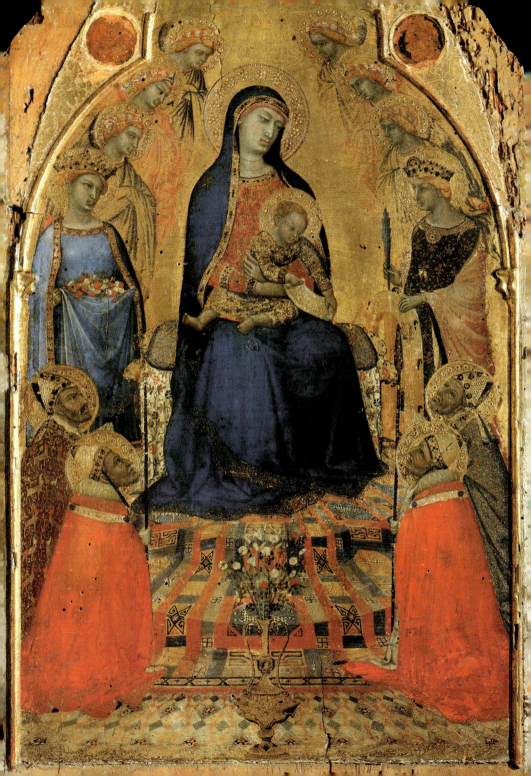

58 Around 1340 Ambrogio painted another, smaller Maestà, now in the Siena Pinacoteca. It was probably part of a triptych, the side panels of which Gordon Moran and Charles Seymour have identified as the two fragments showing St Nicholas of Bari giving alms (in the Louvre) and St Martin and the poor man (now in Yale University Art Museum, New Haven). These two saints also appear in the central part of the triptych. Also from the document discovered by the two scholars, we learn that the work was originally painted for the Hospital of Santa Maria della Scala in Siena, who presumably commissioned it to begin with, as can be inferred also from the choice of stories of charitable behaviour. In the central part we see the Madonna enthroned surrounded by angels, with St Dorothea offering flowers, St Catherine with the spiked wheel on which she was tortured and a palm frond (the symbol of martyrdom), and two bishops, Martin and Nicholas, as well as two popes which can be identified thanks to a partially missing inscription on their stoles as Clement and Gregory. Once again, the Virgin has the same sad and sorrowful expression as in the Massa

57 Marittima Maestà: crossing her arms, she clutches to her breast the Child who is, on the contrary, turning in a rather carefree and lively way to the right, displaying the scroll on which is written *Fiat v(oluntas tua)* between two red lines that are rather reminiscent of a ladder. . . probably not by chance for the painting is in the hospital "della Scala." It was with these words

that the Virgin accepted humbly the Angel's message, and they are to be considered an invitation to the sick, or to those who in any case have been sorely tried by life, who prayed in front of this little altar, to accept with the same humility the sorrows assigned to them by God. Another suggestion of Charity, in its twofold meaning of *amor Dei* and *amor proximi*, is in the figures of the two female saints, for Dorothea is given the attribute of flowers and can therefore be interpreted as merciful Charity, and Catherine bears the wheel of her martyrdom, the symbol of her love for God, for whom she did not hesitate to sacrifice her life. The same meaning can be attributed to the other pair of saints, frequently to be found in Ambrogio's work, St Dorothea and Mary Magdalene (in the polyptych in 47 this same Pinacoteca, where Mary Magdalene bears the object of her love on her breast, and in the Sant'Agostino Maestà, all the more so since the two figu- 5 res of Charity in the Maestà in Monte Siepi are por- 54 trayed according to an iconography which makes them very similar to these two saints).

This small painting has been quite rightly praised by scholars and considered a true masterpiece, for its splendid colours and chromatic combinations, for its masterful composition and the original use of perspective, as well as for its overall sense of dramatic pathos, all in just these few centimetres: it is, as Paolo Torriti has pointed out, like a shining jewel.

The Stories of St Nicholas at the Uffizi

The four small paintings with stories from the life of St Nicholas, which were originally probably placed at the sides of a large painting of the saint, come from the church of San Procolo in Florence; these four panels 50 are now at the Uffizi, like the triptych from the same church we mentioned earlier. Once again, Ambrogio illustrates the subject of Charity, one of the recurrent themes of his work, which he will continue to use, as 69 we shall see, in the frescoes of the Martyrdom of the Franciscan Monks in Siena, an example of total self- 49 sacrifice; even the subject of the Madonna del Latte, which owes its popularity at this period to Ambrogio's painting, is conceived as an illustration of this Virtue, for we must not forget that one of the representations of Charity shows her feeding two infants at her breasts.

In these four panels Lorenzetti principally concen-

trates on the problem of organizing within such a small space scenes with a very complex narrative structure, and he also studies space and perspective representation, resorting to daring superimposition of different planes and depths. Let us begin with the Ordainment 5 of St Nicholas, which Lorenzetti places in a three-aisled church, with the altar situated in a raised crossing and the apse surmounted by a dome. The protagonists of the scene not only move amongst the pillars of the nave in a very natural way, but they even go down some steps around the back of the altar, thereby suggesting a spatial depth that goes well beyond what has actually been painted.

In the scene of the Resurrection of the Little Boy, 60 Lorenzetti deals with the same problems of spatial organization, as well as the more specifically narrative ones. The story begins on the upper level, where the

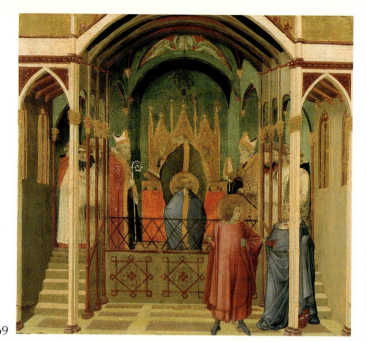

59. Stories of St Nicholas: Ordainment
cm. 92 x 49
Florence, Uffizi

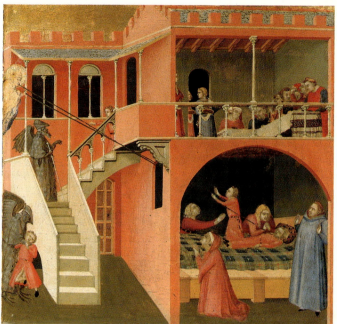

60. Stories of St Nicholas: Resurrection of the Boy
cm. 92 x 52
Florence, Uffizi

father is celebrating his saint's day with a banquet in honour of his youngest son. This is the first time, in Italian painting, that a narrative account begins at the top; by doing this the artist manages to unravel the story leading the spectator along a shell-shaped path down the steps, to the ground-floor room, where the miracle actually takes place; at the same time he makes the characters of the story move from the back of the room to the foreground, to the steps and in front of the bedroom, and then go back inside the dark interior for the bed scene. In the banquet room Ambrogio has placed two servants in strategic positions: one is leaning against the wall that divides the room from the stairway and thus draws our attention and makes us leave the room, together with the child; the other, looking out from the door at the back of the room, suggests a depth of space that goes beyond the spectator's vision. The sense of depth is further increased by the sharp foreshortening of the L-shaped table, with a perspective which is slightly overturned. Then the boy goes down the stairway, attracted by the fake pilgrim, who is portrayed again on the other side of the steps (another way of indicating a spatial depth which continues beyond one's range of vision), as he strangles the boy with his claw-like hands. The scene now moves to the right, to the bedroom, where first the dead child is mourned and then, like a film screened in slow motion, he comes back to life amidst the wonder of his family. The life-giving rays which pour forth from the mouth and the hand of St Nicholas, shown in mid-air to the left, reach the head of the boy as he lies on the bed through the open window; these rays move perpendicularly to the stairway and mark an intermediate level between the foreground, where Lorenzetti has placed the members of the fami-

ly, already aware of the miracle that has taken place, and the women in the background, still mourning the child's death. Another interesting element, and a novelty as well, is the attention given to the child, rarely taken into consideration in the Middle Ages, who here becomes the protagonist of the story; too many children died before reaching adulthood, so that they were not normally thought of as having their own identity and individuality — this is why the Christ Child was so often portrayed as a little adult. And Lorenzetti is quick to grasp the development of this new feeling of love and fondness for children: in the Good Government frescoes, amidst the animated view of the city, there are a few barely sketched children's heads.

The third episode, St Nicholas and the Poor Girls' Dowry, shows the saint, who is still a layman, intervening to solve a difficult family situation: a father, since he cannot provide a dowry for his three daughters, decides one evening that the following day he will force them into prostitution. So Nicholas throws three gold balls (and they will be his attribute thereafter) through the window; this will make it possible for the girls to be married. And, in fact, Lorenzetti, always a careful observer of reality, transforms the symbolic gold balls of traditional iconography into gold bars, undoubtedly closer to the spectator's experience.

In this painting Lorenzetti has given us a particularly Sienese scene, especially the doorway of the palace in the background with its two arches, one round and the other pointed, and a wealth of realistic details: arched windows divided into sections by little colonnettes, seats along the street. And it is these seats, shown in foreshortening one in the foreground and the other in the background, that convey the idea of the depth of

51

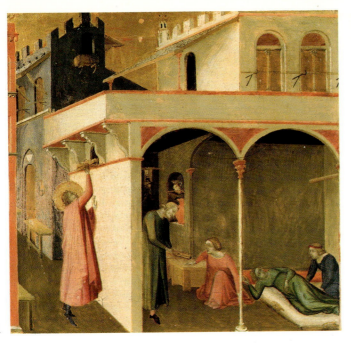

61

62

the street. Even the house where the miracle takes place is shown at a slanting angle: inside, the worn mattress is placed diagonally, the niche in the wall with the jugs further divides the space, a metal rod stands out from the wall and holds the towel, and the simple chests placed at the corners and the lantern at the edge of the inner arch are used to give more movement to the space. In this scene, too, the story continues out of doors, and the exterior has the same psychological importance as the interior. The splendid portrayal of Nicholas, standing on the tips of his toes, with his red cloak, stands out against the white wall, as he stretches up to the little window; the saint's body, a collection of foreshortenings and acute angles, is echoed in the background architecture, also portrayed from that same perspective angle; the architectural background culminates in the roof of the terrace, even though here the actual execution is not that successful.

62 The Miracle of the Wheat, which two angels pour from open bales in the sky down onto the boats of the poor fishermen, is the first example of a seascape in painting and marks the birth of a new genre: the landscape. Even though Lorenzetti is still a painter of his times, in the sense that the scene is not yet organized around a single vanishing point, he nevertheless succeeds in giving the water a sense of depth, thanks to the buildings and the rocks along the shore which mark the increase in distance, as well as the boats that become smaller against the vast horizon (a long line painted at the end of the green wall of water), which communicates, with its incumbent mass, a sense of limitless size. This painting is normally dated around 1332, which means at more or less the time as the San Procolo triptych; it is evidence of how Ambrogio investigates the problems of narrative composition and of perspective at the same time, with great constance and coherence.

61. Stories of St Nicholas: The Poor Girl's Dowry
cm. 92 x 49
Florence, Uffizi

62. Stories of St Nicholas: Miracle of the Wheat
cm. 96 x 52
Florence, Uffizi

63. Presentation in the Temple
cm. 257 x 168
Florence, Uffizi

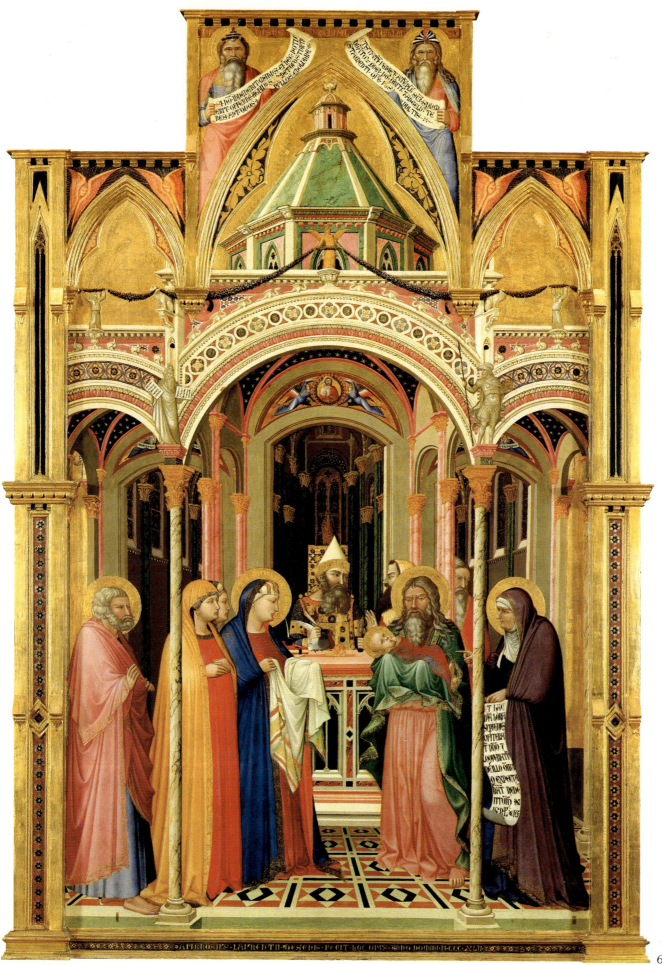

63

The Presentation in the Temple and the Annunciation

63 In 1342 Ambrogio painted a Presentation in the Temple for the Chapel of San Crescenzio in Siena Cathedral; the painting is now in the Uffizi. It is one of his few dated works (1342) and, as a young American scholar, Kate Frederick, has recently demonstrated, it was part of a wider programme, which had been carefully organized from the beginning and took twenty years to complete. The four chapels placed at the corners of the crossing, where the nave and the transept of the Cathedral meet, contained, starting from the chapel to the left, the Chapel of San Savino, and

15 moving clockwise: Pietro Lorenzetti's Birth of the Virgin, painted in 1342; Simone Martini's Annunciation, painted in 1333, in the Chapel of Sant'Ansano; Andrea di Bartolo's Birth of Christ (now lost), painted in 1351, in the Chapel of San Vittorio; and lastly, Ambrogio's Presentation, painted in 1342, the same year as his brother's altarpiece.

64

Here Ambrogio continues and perfects the research he had begun in the painting of the Ordainment of St 59 Nicholas. He gives us the same perspective representation of the three-aisled church, shown at the crossing; here, however, he attempts a much more complex perspective study, with the columns of the three aisles, the view of the triumphal arch at the height of the dome with the figure of Christ supported by two angels, and at the same time the portrayal of the exterior of the building as well, crowned by the octagonal lantern. The artist is illustrating the passage from the Gospel according to Luke (2: 22-39), which in fact combines two different stories: the Presentation of Jesus in the Temple, thirty days after his birth, and the Purification of the Virgin, forty days after childbirth; Luke also adds here the prophecies of Anna and Simeon. Ambrogio decided to portray the scene at the moment when the two prophets are speaking. All the characters are motionless, fully aware of the gravity of the occasion. The sense of magic suspension is emphasized by the empty space that divides the two groups, further stressed by the presence of the priest who is about to circumcise the Child, for he is indeed at the centre of the scene, but he is placed at a distance, behind the altar, where Lorenzetti has also painted the sacrificial doves, also totally motionless. The perfect balance that Ambrogio has succeeded in creating between the speculative aspect and the emotional one is evidenced by the strongly human juxtaposition of the old Simeon, so tired and wrinkled, and the carefree gesture of the infant, sticking a finger in his mouth; a rather surprising gesture, when attributed to Christ, but which on the one hand shows the loving attention that Ambrogio devotes to the world of childhood, and on the other conveys the real humanity of this God made man.

The task of explaining the scene and the importance of the occurrence is entrusted to the prophetess Anna, 64 who points towards the Child with her forefinger and unravels a scroll with the following inscription: *Et haec ipsa hora superveniens confitebatur Domino et loquebatur de illo omnibus qui expectabant redemptionem Israel* (And she coming in that instant gave thanks likewise unto the Lord, and spake of him to all them that looked for redemption in Jerusalem); the passage is from the Gospel according to Luke (2: 38). The theme of salvation is announced by Moses and Malachi, who are added, as "extras" as it were, on either side of the dome; Moses carries a scroll with an inscription from Leviticus (12: 8): *(Quod) si non invenerit manus eius nec potuerit offerre agnum, sumet duos turtures vel duos pullos columbarum (unum in holocaustum et alterum pro peccato)* (And if she be not able to bring a lamb, then she shall bring two turtles, or two young pigeons; the one for the burnt offering, and the other for a sin offering). Malachi holds

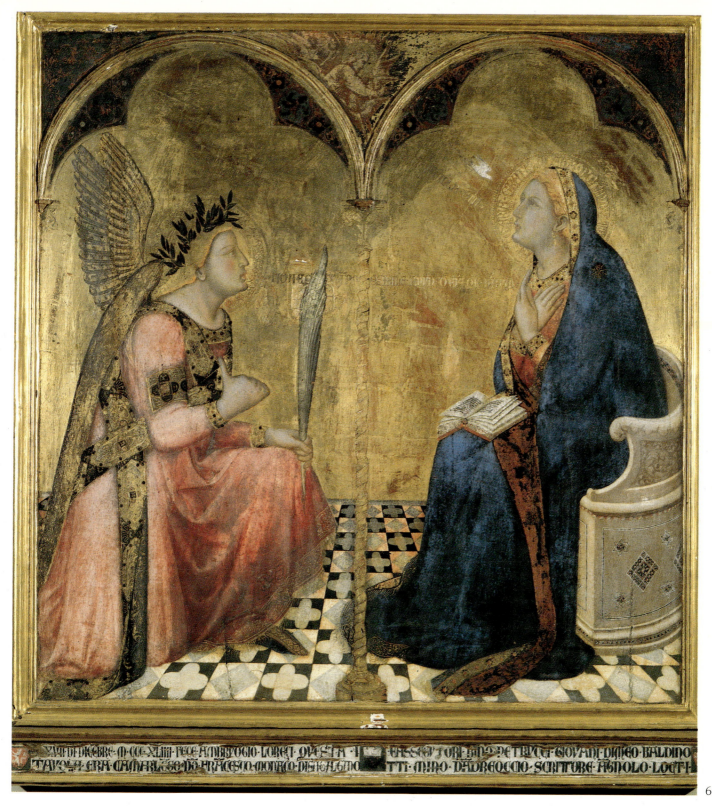

65

64. *Presentation in the Temple, detail*
Prophetess Anna
Florence, Uffizi

65. *Annunciation*
cm. 122 x 117
Siena, Pinacoteca Nazionale

55

another scroll, with a passage from the third chapter of his prophecies (Malachi, 3: 1): *et statim veniet ad templum suum Dominator, quem vos quaeritis, et angelus testamenti, quem vos vultis* (And the Lord, whom ye seek, shall suddenly come to his temple, even the messenger of the covenant, whom ye delight in). The two biblical characters, in perfect harmony, introduce the two themes of purification and redemption.

65 In the case of the Annunciation, the last work signed and dated by Ambrogio before he died in the 1348 epidemic, the artist has also selected a single instant, the most profound moment, from the account of the event given in the Bible. This painting comes from the Sala del Concistoro in the Palazzo Pubblico in Siena, and is now in the Pinacoteca of the same city. Inscribed along the base of the painting is the year, 1344, and the name of the artist, Ambruogio Lorenzi, as well as the name of his clients, the Tax Magistrates of that year, among whom the Camerlengo (or chamberlain) was Francesco, "a monk from San Galgano," further evidence of the long-standing relationship between the Commune of Siena and San Galgano and Monte Siepi. Unfortunately this painting has been subjected to retouching and clumsy restoration. Scholars are not in agreement, for example, about the problem of the angel's wings (at present he has four, two folded and two open), although, in a recent article, Norman Muller maintains that the open ones are to be considered original, whereas the others were added during a later restoration, for the original ones were obviously thought to be too small. But his opinion is not agreed upon by all scholars. What is certain, though, is the demonstration, also proposed by Muller, that the angel's words, inscribed on the gold background of the painting, were originally in the future tense, and not in the present as they are now. The inscription should read: *non erit impossibile apud deum omne verbum* (For with God nothing shall be impossible, Luke, 1: 37).

In the Gospel according to Luke (1: 28-38), the narration covers five different moments: the arrival of the Angel and his greeting, which causes such wonder in Mary; the message; the explanation of how this event will take place, since Mary "knows not a man"; the moment when she accepts; and, lastly, the Angel's departure. Ambrogio has chosen to illustrate the last part of the dialogue between Mary and the Angel, but according to an iconography that is totally original. The Virgin, who still has her book open on her lap, for she was deep in meditation, folds her arms on her breast and utters the phrase that indicates her acceptance: *Ecce ancilla Domini* (Behold the handmaid of the Lord). But she does not look at the Angel: she turns her gaze towards heaven, where Christ, and not God the Father, is sending her the dove of the Holy Ghost. Ambrogio is therefore emphasizing the moment of the Incarnation, which is referred to also by the Angel's thumb pointing backwards, indicating someone who is not present. The separation between Mary and the messenger, who has concluded his mis-

sion with his final words, is stressed by the colonnette, so that the two figures, although sharing the same space, are separated for they are meditating in different ways on the same idea. And this is why the Angel's greeting, *Ave Maria, gratia plena, Dominus tecum* (Hail Mary, full of grace, the Lord be with you), has been placed on the Virgin's halo, to indicate that she is saintly; otherwise they would have implied a direct dialogue. Another unusual feature is the palm-frond that Lorenzetti places in the Angel's hand, for it is a symbol of victory in martyrdom (Dante, in *Paradise* XXXII, 112, talking of Archangel Gabriel, describes him as "he who brought the palm below to Mary"). Medieval commentators interpreted it in this way, that is that Mary took the prize over all other creatures in pleasing God, because of the humility with which she accepted her destiny.

The olive crown, resting on Gabriel's blonde hair, is the symbol of Peace and reconciliation between God and all his creatures; but, since in the Middle Ages peace could only be achieved by the defeat and annihilation of the enemy (and we shall see this better when we examine the figure of peace in the Good Government), this green crown is also a reference to Christ's definitive victory over Satan: another detail which was intended to make the spectator meditate on the mystery of Incarnation.

As is common in the work of Ambrogio, the architectural construction blends admirably with the meaning of the scene itself. Here, the moment of magical suspension, the subtle instant between the understanding of the heavenly message and the immediate consequences, is conveyed also by the deliberate ambiguity of the spatial construction. On the one hand, in fact, Lorenzetti makes the tiled floor converge with geometric precision towards a single vanishing point, whereas then this realistic perspective reconstruction is thwarted, for he makes it clash against the immaterial end wall, where the gold light suggests the abstraction of Paradise.

66. City by the Sea
cm. 22 x 32
Siena, Pinacoteca Nazionale

The Disputed Paintings: Which of the Brothers is the Author?

In the Siena Pinacoteca there are three small paintings, an Allegory of Redemption and two landscapes, a City by the Sea and a Castle on the Shores of a Lake, which have been the subject of much debate by scholars, both in terms of attribution and also as to their possible original function. We shall analyze them following the opinion that seems most likely, without any certainty of being correct. Let us start with the two landscapes.

These two famous paintings, if they had been painted as we see them now, according to Enzo Carli (whose opinion I shall follow also in other statements) would be the first example in Italy of "pure" landscapes. Various other scholars, however, see them as fragments of the revolving globe, a work that was so famous that the Council Hall it stood in was named after it. Recent technical analyses of the wood fibre, looking for traces of supports or of cuts, have led us to conclude that the paintings are substantially whole and that they were originally laid out one above the other (together with other panels now lost) and surrounded by frames. It seems most likely that they formed the doors of a cupboard "which contained documents concerning the places illustrated on the paintings." Carli has identified the city by the sea as the fortress-town of Talamone, also since the little

figure of a naked woman in the small bay to the right is sitting in an area which to this day is still called "women's bathing place." The castle on the shores of a lake, on the other hand, is a castle built at the border of the Sienese state, on Lake Chiusi or Lake Trasimene. The suggestion that the two panels were part of the globe is refuted by the fact that, since the globe was revolving, the paintings could not be placed vertically above each other. Carli quite rightly stresses that "even though their role was a purely functional one, comparable to the illustrations on the covers of the Biccherna or Gabella registers, this did not prevent Ambrogio from imbuing these two 'topographical' documents with an unmistakable sense of poetry."

Our modern artistic taste is very much taken by this illustration of a deserted city in the full sunshine, with all the roofs and streets seen from above, to which a touch of mystery is added by the bather shown from behind and the little boat, all alone sailing across the gulf. This same sense of silence is conveyed by the other empty boat, moored on the shore of the greenish lake, in the second landscape, where the barren clay hills and the spur of rock in the foreground separate and sever all communications between the woods and the other darker hills on one side and the softly swelling waves of the lake on the other.

66

67

67. *Castle on the Shores of a Lake cm. 22 x 33 Siena, Pinacoteca Nazionale*

68. *Allegory of Redemption cm. 57 x 118 Siena, Pinacoteca Nazionale*

These two paintings are splendid examples of Ambrogio's great pictorial mastery, and we feel that we cannot accept the theory proposed by Federico Zeri, that they are about a century later and the work of Sassetta, painted between 1423 and 1426 for the altarpiece commissioned by the Arte della Lana.

Let us now look at the Allegory of Redemption, which is unfortunately in very bad condition, making our appreciation of this masterpiece more difficult. The daring conception of this painting is so extraordinary that we believe it can only be the work of Ambrogio: for he does not hesitate to place amidst the pile of corpses of the Triumph of Death the body of Christ himself, whose life was also terminated by the huge scythe that the terrifying winged skeleton, flying above the cross, is wielding. To have assigned to Death such

enormous power is the mark of an artist with a truly exceptional mental freedom, ahead of his times. Although the painting is small, the scene has an extraordinary narrative intensity (the scrolls without inscriptions may suggest that the painting was just a preparatory sketch for a fresco or for a larger work).

The narration begins in the upper lefthand section, with Adam and Eve's sin, their shame and expulsion from Earthly Paradise, chased away by the fiery angel. In front of them is Death, with bat's wings and a huge scythe, and this means that from this moment onwards spiritual death (the monstrous creature has the appearance of a demon) and physical death are part of the world: and, in fact, below we see Cain killing Abel. In the middle, the crucified Christ is shown above a pile of decomposing corpses. Little groups of

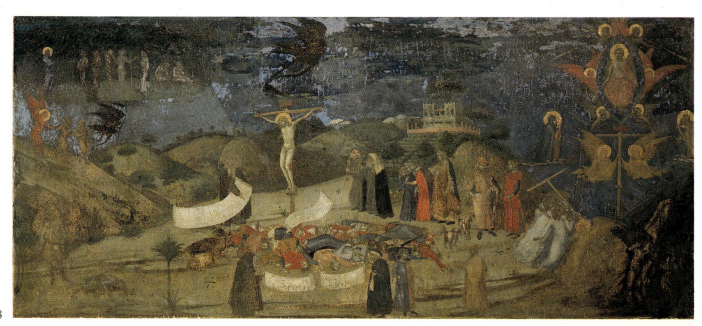

68

living people comment the scene; they are chosen to represent different social categories and different ways of life. Thus we have a hermit, a group of poor and derelict people, two knights hunting and some splendidly dressed ladies (gay and pleasure-seeking, unaware of the afterlife) and what are perhaps two philosophers strolling. To the right, Christ the Judge, with his feet on a rainbow, is surrounded by angels bearing the symbols of his passion with the Virgin and John in the role of intermediaries, while other angels force the souls of the damned down into Hell. In this gloomy vision of the afterlife there is no Paradise, and this and other analogies in the choice of the symbolic groups suggest that Lorenzetti studied in depth the frescoes in the Pisa Camposanto. The artist, possibly in the midst of the raging plague epidemic, conceives of Death not simply as a divine law or decree. As Alberto Tenenti so rightly says: "(Death) has become a terrifying reality, a force that does not hesitate to use its power at any moment: even against the man-God." Death conquering even Christ "is an element which no one had suggested before or since."

For all the reasons mentioned and also because of some obvious analogies with the Good Government frescoes (the turreted city of Earthly Paradise is very much like the splendid building in the countryside just outside Siena; the figure of Death is reminiscent of Timor, while the dying Abel recalls the outstretched woman, both in Bad Government), I believe that this panel was painted in the last period of Ambrogio's life.

The Frescoes in the Church and Cloister of San Francesco in Siena

The frescoes in the cloister of San Francesco, mentioned for the last time in 1730 when they were barbarously whitewashed over, were the works by Lorenzetti that Ghiberti appreciated most and the ones on which he had based his very high opinion of the Sienese master ("it seems to me a wondrous thing for a painted story"). Ghiberti does not give us the names of the Franciscan martyrs illustrated in the frescoes, nor does he report the inscription, now lost, but which was recorded in the 16th century by Sigismondo Tizio. This inscription is decisive for the identification, for it refers to a Sienese Franciscan, Pietro; but at least two Sienese martyrs, both honoured in the church of San Francesco, bore this name. Thanks to the interpretation given by Ghiberti and his long and glowing description, Seidel has recently been able to reconstruct the programme of the eastern wall painted by Lorenzetti, and to give the fragments of frescoes that have recently been rediscovered a correct explanation. This fragment illustrates the city of Thanah in India (present-day Bombay), where on 9 April 1321 the martyrs Tommaso da Tolentino, Jacopo da Padova and Demetrio da Siena were put to death (the young Pietro was killed elsewhere). In the fragment of the fresco we can clearly make out the storm of rain and hail that followed the execution, and which had so impressed Ghiberti: "and when the said monks were beheaded, there began a storm with darkened sky, hail, lightning, thunder, earthquakes; it seems from the painting that both heaven and earth are in danger, it appears that everyone is overcome by great fear and seeks shelter; men and women covering their heads and the armed soldiers shielding their heads with their flags, and it truly appears that the hailstones are bouncing off the flags pushed by wondrous gusts of wind. You can see trees bending to the ground, and some breaking, and everyone is fleeing. . . It seems to me a wondrous thing for a painted story."

Together with his brother Pietro, Ambrogio Lorenzetti is the first medieval painter to record weather changes. Ghiberti's lengthy description of the other frescoes, where the artist had been particularly successful in his portrayal of feelings and emotions (for example, the two henchmen who are worn out after having flagellated the monks, "with matted hair, dripping sweat, panting and breathless, it is a wonder to see the master's art"), makes us realize what a terrible loss the whitewashing over of these frescoes has been.

So we learn that Lorenzetti, shortly before the Good Government frescoes, had worked on a monumental composition, painting on the east wall seven scenes illustrating the journey, the disputation in front of the Sultan and lastly the execution of the four Franciscans martyrs. The frescoes continued in the Chapter Hall of the monastery, where he had painted the death of another Franciscan martyr, and his brother Pietro had painted a Crucifixion. As Seidel points out, in observance of the principle of imitatio Christi, in Siena and in other Franciscan monasteries the representation of the sacrifice of Christ was extended to the illustration of the martyrdom of Franciscan friars. Seidel also proves in a very convincing way that the cycle was conceived as a single work of art and all at the same time. In 1857 two scenes painted in the Chapter Hall were removed from the wall and placed in the church, where they still are today. They depict the Martyrdom of seven Franciscans in Ceuta in Morocco and St Louis being received by Boniface VIII (some very

69

beautiful portraits of Poor Clares are today in the National Gallery, London).

In the fresco of the Martyrdom, inside an octagonal temple we see the sultan, with his drawn sword resting on his knees and a fearful angry expression on his face; at a lower level, on a wide step, Lorenzetti has placed two groups of soldiers and court dignitaries with splendid Oriental headdresses, each one portrayed in great detail and showing a wide variety of emotions, from a rather self-contained reserve to an open expression of horror (particularly strong in the group of Tartar women). And finally, in the foreground, the actual scene of the martyrdom: the severed head of a monk, with his mouth gaping in an expression of all too human suffering, is an unforgettable detail, like the executioner, at the far right, who is putting his sword back into its sheath and whose hair is all rumpled, his face a mask of cruelty, the muscles of his arms bulging with terrifying strength. By placing the three groups on three different planes, the artist achieves an immediate sense of depth, conveyed also by the octagonal building with cross-vaults; on the pinnacles of the temple and at the intersections of the arches there are seven statuettes, showing four women and three warriors, each with attributes (animals or objects) of classical origin: in his book on Ambrogio,

70

71

Rowley has attempted to interpret these figures as Virtues, suggesting that the evil sultan and his wicked rule were opposed by the civic Virtues of a good government. This theory is very ingenious, but it would imply a very cynical idea of power in the sultan (and in Ambrogio); and, in any case, how could the Virtues be shining bright at precisely the moment when so much cruelty is being practised? The correct interpretation is the opposite one proposed by Meyer L. Shapiro, who identifies the seven figures as the seven Deadly Sins: starting from the left, the woman with the two baskets in her hooked hands, a lighted candelabra on her head and a dog is Avarice, and the source for this description is in Boethius (*De Consolatione Philosophiae* II, V, 25) when he says that the "love of possession burns more furiously than the fires of Etna." The dog, as we learn from Phaedrus's fable (I, 27), is an appropriate symbol, for he dies rather than stop guarding the treasure. The following figure is Gluttony: a woman pouring out the contents of two jars, that is wasting as long as she can satisfy her insatiable appetite (there is a play on the word *effundere* here, meaning both pouring out and exhausting, or satisfying); the bear in the Bible (Proverbs 28: 15) is the symbol of insatiable appetite. Avarice and Gluttony, to be understood also in the sense of prodigality,

form a perfect antithesis. The third woman, bearing the Gorgon's severed head and with an unsheathed dagger, a flame on her head and a wolf at her feet, is Bellona, the sister of Mars: she symbolizes Wrath, always ready to bring discord and death. The fourth woman, with a bow and arrows and being embraced by a winged Cupid, is Venus: lust, therefore, and more specifically the form of lust that leads to Sloth and to weakness, as Ovid writes in his *Remedia Amoris* (lines 135-150). Here, too, the two women form an antithesis. Between them, at the top of the pediment, there stands a warrior entirely clad in armour, with an enormous shield and a threatening arrow: this is Mars, connecting element between the two women, portrayed here, because of his ties with Venus, as Lust (see, once again, Boethius, *De Consolatione* III, 10, 1-3, for the detail of the crossing bands on the armour). The horse at his feet is the *equus luxurians* mentioned by Virgil (Eneid 11, 49). On the pediment to the left there is another warrior, a bold young man accompanied by a lion, the symbol of Pride (St Paul, I. Tim. 3: 6). This warrior is Alexander the Great, described by Seneca (*De beneficiis* V, 6, 1) as "a man swollen with a superhuman and measureless pride." Lastly, the warrior standing on the main pediment, now covered by an ornamental border, must be Envy; he was probably portrayed as blind, as Dante imagines sinners being punished for this sin (Purgatory XIII, 67), playing on the etymology of the word *invisus*; or perhaps Lorenzetti intentionally portrayed him like this, cut off in the middle by the frame? One thing is for sure, that Ambrogio arranged the Sins or Vices in a very careful hierarchical order, in distinct contrast to the Virtues of the Franciscans, and of these Franciscans in particular, about to be slaughtered. At the top he has placed Envy, for it is the opposite of Charity, the greatest Virtue of these martyrs, and also because, as the Book of Wisdom (2, 24) says, it was as a result of "the devil's envy that death was introduced to the world." Poverty, obedience, chastity and humility, the four main Virtues of the Franciscan Order, are contrasted to the Vices of Avarice and

70

Gluttony, Wrath, Lust and Pride.

Ghiberti, in his enthusiastic praise of Ambrogio, admires his interpretation of doctrine and his special attention to classical antiquity; and, in fact, when a statue of Venus (a Roman copy of an original by Lysippus) came to light during the excavations for the foundations of a house in Siena, Lorenzetti made a drawing of it. And these are the two aspects that are most to be admired here: the speculative aspect, his uncommon originality of inspiration, blends with an extraordinary compositional talent and a perfect rendering of the emotions depicted.

In the fresco of St Louis being received by Boniface 72 VIII the representation of space, which had already been investigated in the previous fresco, reaches a level of considerable coherence. We need only compare

*70. Martyrdom of Seven Franciscans,
detail of the Tartar women
Siena, San Francesco*

*71. Martyrdom of Seven Franciscans,
detail of the martyrs
Siena, San Francesco*

71

72

the composition of this scene with the same subject painted by Pietro in a section of the predella of the Carmelites' Altarpiece (the Approval of the New Habit), to notice how Ambrogio is able to make crowds move in space in a much more convincing way. Ambrogio has arranged the onlookers on four different planes. In the foreground we have the cardinals seen from behind and, symmetrically, on the oppposite side, the high prelates, with Robert of Anjou among them. With a crown on his head and a weary, meditative expression, he looks at his brother in the centre, who is delivering his regal dignity in the hands of the Pope; to make the scene even more full of movement, the Pope is seated high above, on a throne placed inside a large niche. Behind the row of cardinals, we see the approaching laymen anxious to witness the ceremony: this is a splendid collection of portraits, of gestures and detailed costumes, arranged in small groups, emphasizing the different perspective views of the hall where the ceremony is taking place.

12

73

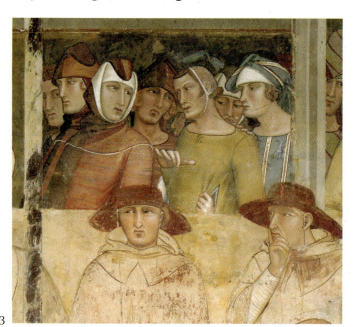

73

The Frescoes in the Palazzo Pubblico of Siena

A series of payments documented between 1338 and 1339 proves that this was the period in which Ambrogio Lorenzetti frescoed in a hall in the Palazzo Pubblico the scenes of Good and Bad Government and the effects of both on the city and on the countryside. The frescoes were commissioned by the Council of Nine who ruled the city of Siena at the time. These titles, which are by now universally accepted, in fact come from the interpretation and description of the famous frescoes given by Achille Lanzi in 1792; before that, as we learn from Ghiberti's *Commentaries* among others, they were simply called Peace and War. Although we shall use the modern titles, we must not forget the earlier names or we might run the risk of misinterpreting the meaning of the whole cycle.

81 Ambrogio made the most of the layout of the room itself, for he painted on the short wall (to one's right as one enters) the allegorical representation of Good Government, which is thus entirely bathed in the sunlight coming from the window on the opposite wall. 87 On the adjacent wall (to the right) we see the city of 90 Siena and the surrounding countryside, and here, too, Lorenzetti uses the natural lighting of the room, for as one gradually moves away from the reassuring protection afforded by the city the landscape becomes darker and darker. On the wall opposite (the wall facing the observer when he enters the room), we have 77 the depiction of Bad Government and War, and of 78 their effects on Siena (where they have already taken 80 up residence) and on the countryside, ravaged and barren; this spectacle of atrocities and violence, where fire and death reign supreme, forces the spectator to meditate on the grave consequences of a mistaken political conduct, both in the form of government and in the participation of the citizenry in the public life of the city. But this scene also makes the spectator turn towards the positive elements of this fresco cycle,

which are thus presented as the only possible solution, without alternatives. Above and below the frescoes there are two friezes containing medallions; unfortunately over the years they have been restored and repainted several times. In the part of the cycle depicting Peace, the frieze below the frescoes showed the 74 Liberal Arts, divided into the Trivium (Grammar, Dialectics and Rhetoric — the latter has been lost) and the Quadrivium (Arithmetic, Geometry, Music, Astronomy, with the addition of Philosophy); the frieze above the frescoes illustrates the planets and the seasons, portrayed in the traditional order, Venus, Spring, Mercury, Summer and the Moon. The frieze below the scene of War, on the other hand, contained portrayals of the tyrants of antiquity: the only one that has survived is Nero, shown as he flings himself onto 75 his own sword. In the frieze above are the remaining planets, Saturn, Jove and Mars, and the remaining seasons, Autumn and Winter. The distribution is such that the negative elements of planets and seasons, like the weapons of Mars or the cold weather of Winter, 76 fall in the "negative" part of the cycle. A collection of inscriptions is provided to illustrate the various images: *Timor* and *Securitas* within the frescoes hold two large scrolls, and another scroll has been placed below the procession of the twenty-four characters in the allegorical section of the Peace scene, to emphasize the positive aspect of the well-governed city; a long inscription runs just under all the frescoes, right above the friezes, providing a continuous sort of running commentary to the images above, many of which are further explained, in the fresco itself, by other annotations.

Let us turn to the wall of the Bad Government, the wall the spectator is obliged to see before the rest. The fact that both the allegory and its effects are confined to a single wall surface creates a rather cramped depiction of reality, which is in line with the painter's inten-

74. *Allegory of Grammar, detail of the frieze*
Siena, Palazzo Pubblico

75. *Portrayal of Nero, detail of the frieze*
Siena, Palazzo Pubblico

76

77 tions: to convey, at first glance, an immediate and meaningful vision of an impolitical situation, thereby making the spectator turn away, as we said earlier, towards the other walls which portray the comforting antidote. At the centre of the dais sits *Tyrannia*, with the appearance of a demon, with horns and fangs, a horrifying face that also exhibits the features attributed to Babylon, the infernal city, in Revelation (17: 3-4). For the figure of Tyranny has flowing woman's hair, a cloak with gold embroidery and precious stones, a gold cup in her hand and a goat, the traditional symbol of lust, at her feet. According to Revelation, the golden cup has the same meaning, for it was "full of abominations and filthiness of her fornication." At her feet is vanquished *Iustitia*, wearing her traditional attribute: in fact, the scales are broken and scattered around her on the ground. Around Tyranny's throne, just a little below her, are gathered the other Vices: (from the left) *Crudelitas*, a horrifying old woman shown in the act of strangling an innocent child, *Proditio* (Betrayal) holding a lamb whose tail ends with a scorpion's poisonous sting, and *Fraus* (Fraud) with bat's wings and clawed feet, demon features. And then there is *Furor*, a monster who is half man and half beast and who resembles the Minotaur described by Dante in Canto XII of the *Inferno* (11-13) and who symbolizes *ira bestial* (animal wrath); in his hand he holds a short dagger and at his feet there is a mound of stones, the instruments for sudden and recurring urban uprisings. Next is *Divisio*, another female figure bearing the colours of Siena, sawing her body in two with a large saw, a reference to the disagreements that were tearing the city apart: the words *Si* and *No* are visible on her two-coloured costume. And so we come to the last Vice, a warrior entirely clad in armour, with *Guerra* (War) written on his shield. Above Tyranny there are another three wicked female figures: *Avaritia*, again an old woman with bat's wings and claws holding a press that produces sacks full of coins; *Superbia* (Pride), waving a sword and a completely crooked yoke, for there can be no peace and no concord where the good of the individual prevails upon the good of the community; and *Vanagloria*, a woman looking at herself in the mirror, a Vice that accompanies Tyranny and its ideology. It is interesting to note how Ambrogio changes his use of language as soon as he moves from a general allegory to the more concrete reality of the city, which at the time the fresco was commissioned was overrun by famines, epidemics and continuous insurrections: in fact, the *Si* and *No* are in the language of the people and appeal to their everyday experience, and on the warrior's shield it says *Guerra* and not *Bellum*. Furthermore, the Vices are divided into two groups: the ones to the left refer more to ethical attitudes, whereas those to the right deal with practical behaviour. The dagger, the stones, the saw and the sword are clearly references to the violent contemporary events and are a sort of distorted mirror image of the necessary use of the sword and the severed head carried by *Iustitia* (one of the Virtues in the allegory of Peace), which symbolizes the inflexibility of the law as guarantor of the common good.

Inside the city surrounded by crenellated walls 78 (another reference to the constant need for self-defence), houses are torn down and set ablaze, the streets are full of rubble, the palaces collapse, while all around hoards of soldiers commit acts of violence, killing and maiming. In this city, where loneliness reigns, no one is working; just one artisan, a blacksmith, is 79 forging weapons. In the hilly countryside, too, the 80 only activities are ones of death and destruction, setting fire to isolated houses and whole villages. The countryside is bare and barren, the trees bear no fruit and no one is cultivating the land. The dark colours accentuate this feeling of sadness and squallor. *Timor*, a horrid old hag dressed in rags, with claws instead of hands and feet (she is very much like Death in the frescoes in the Pisa Camposanto), hovers about in the air, wielding a sword and a scroll with the inscription: *per volere el ben proprio in questa terra / sommesse la giustizia a Tyrannia: unde per questa via / non passa alcun senza dubbio di morte / che fuor sirobba e dentro dele porte* (to establish her own good in this land / she subjugated justice to tyranny / so that along this

64

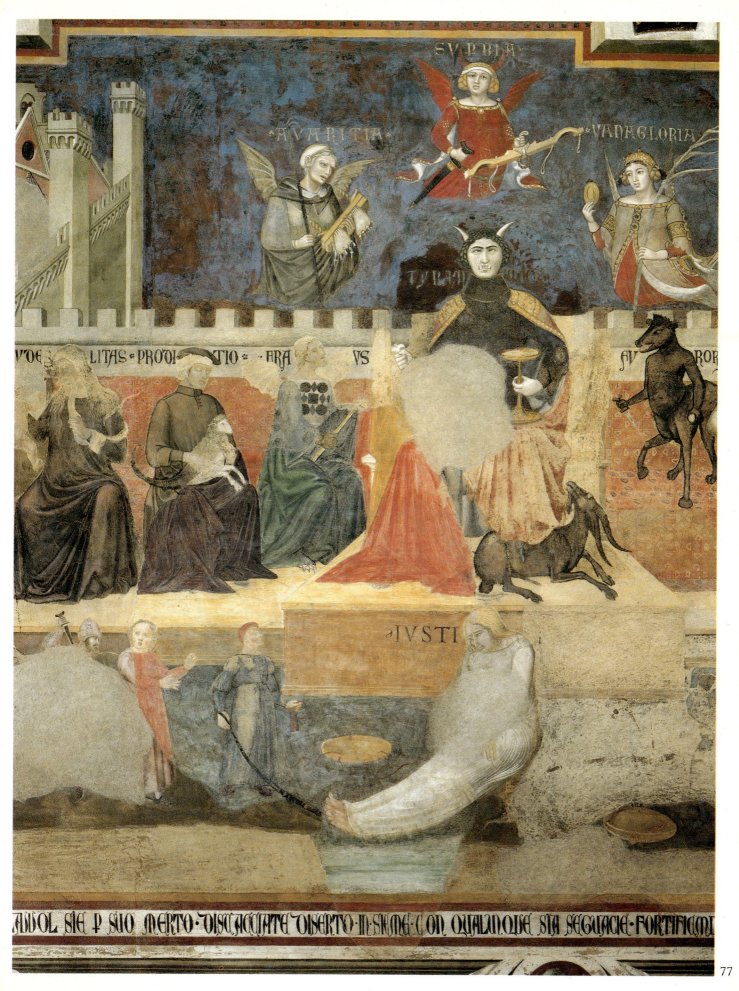

SVPBIA

AVARITIA

VANAGLORIA

TYRAMIDE

LITAS · PRODI··TIO · ARA···VS······AV···ROR

·IVSTI

····DOL SIE P SVO MERTO · DISCACCIATE DISERTO · IN SIEME · CON QUALVNOVE SIA SEGVACIE · FORTIFICHI·····

77

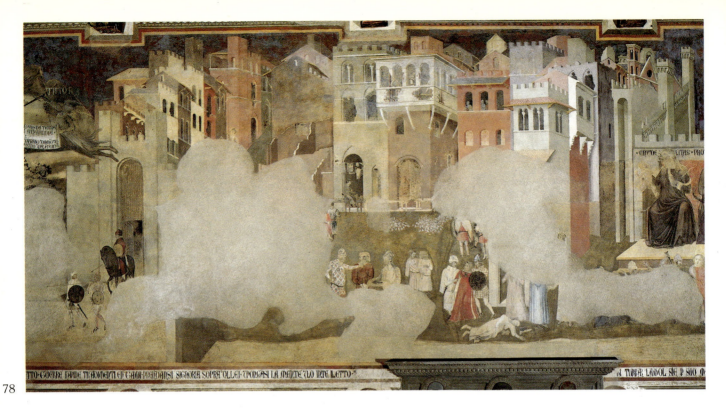

78

79

78, 79. Effects of Bad Government, details
Siena, Palazzo Pubblico

80. Effects of Bad Government, detail
Siena, Palazzo Pubblico

road / no man shall pass without risking his life / for there is stealing outside and within the gates). Fear is in fact the protagonist of this part of the fresco, for it is fear that paralyzes communal life and slams shut the huge city gates while the soldiers on horseback, on their way to wreak havoc and destruction, are still going out.

Let us now look at the allegory of Good Government and of Peace. Above, in the sky, is *Sapientia*; she holds in one hand the Scriptures and in the other huge scales that the figure of Justice, below her, is balancing. On the two scale-pans there are two angels administering justice, *comutativa* and *distributiva* as the inscriptions tell us. In fact, a later restoration is undoubtedly responsible for having exchanged the two words (we know that already in the l5th century some words of the fresco were no longer legible). The last letters of both words are the same, so it is fairly likely that they were misread. To the left must be the representation of *comutativa* Justice, with the angel busy re-establishing the correct balance, rewarding one man with a symbolic crown and punishing the other, cutting off his head. On the other side of the scale, the angel is administering *distributiva* Justice, since he is offering a strongbox full of money, a spear and a staff, the symbol of public office, to two men of high rank, as we can see from their clothes. These two terms come from Thomas Aquinas's commentary of Aristotle's *Nicomachaean Ethics*. The two concepts that this fresco most wanted to stress, as Nicolai Rubinstein so rightly suggested, were the Aristotelian concept of justice in its twofold interpretation, scholastic and juridical, and the concept, also Aristotelian, of the Common Good seen as the subordination of the good of the individual to that of the community; these concepts had also been expounded on by the Domini-

81

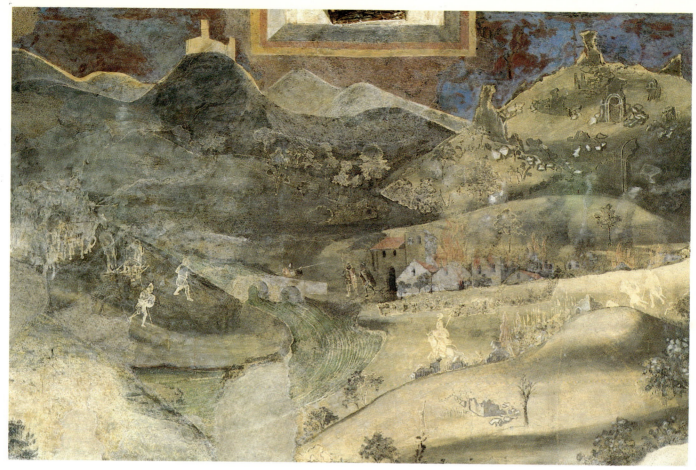

can monk Remigio de' Girolami, who between 1302 and 1304 wrote *De bono pacis*, *De bono communi* and the unfinished *De iustitia*. The two angels show clearly how the rulers of Siena intend to administer justice, carefully spending public money, distributing honours and public offices, but also distributing punishments.

The gigantic figure of Justice seated on the throne is framed by the inscription *diligite iustitiam qui iudicatis terram* (love justice, you who govern the world) which is the first line of the Book of Wisdom and is also the foundation of Lorenzetti's whole allegory, because it is from the figure of *Sapientia*, who undoubtedly holds the *Liber Sapientiae* or Book of Wisdom in her hand, that *Iustitia* is inspired. It is interesting here to remember Dante's complex political allegory in Paradise (Canto XVIII, 90-117), when in order to illustrate the concept of justice he makes this very line appear in heaven: *diligite iustitiam primai: fur verbo e nome di tutto il dipinto; qui iudicatis terram fur sezzai* (Diligite iustitiam: verb and noun, These words came first, and following afterward: Qui iudicatis terram last were shown).

Completely original is the figure of *Concordia*, just below Justice from whom she receives the ropes (or cords) of the scales, which she then delivers to the procession of twenty-four citizens moving towards the Commune of Siena. In her lap she holds a large carpenter's plane, obviously symbolizing this Virtue's ability to smooth out any discord, the opposite of the saw

with which *Divisio* in the Bad Government fresco was mutilating her own body. Concord, who compared to the other Virtues is much larger, and therefore in medieval interpretations of size proportionate to importance, is clearly one of the most important elements of the allegory, sits at the same level as the citizenry: another detail, together with the carpenter's plane, that indicates that she belongs to the real life of the city, for it is Concord that allows the existence of the Commune. The two cords are intended as an explanation of the name, even though the etymology is incorrect; this was a common medieval way of reaching the hidden meaning of a word. So, instead of the correct etymology of *concors* ("with the same heart"), Lorenzetti explains the word as deriving from *cum chorda* ("with a cord"), an interpretation previously proposed by Quintilian. In Cicero, the comparison between the harmony of sounds and the good accord in the city was already explicit: "that harmony which musicians display in song can be compared, as far as the city is concerned, with concord" (*De Republica*, II, 69). Another obvious play on the words concord and musical chords appears in *Paradise* (Canto XXVI, 45-51): *per intelletto umano / e per autoritadi a lui concorde / de' tuoi amori a Dio guarda il sovrano. / Ma di' ancor se tu senti altre corde / tirarti verso lui, sì che tu suone / con quanti denti questo amor ti morde* (By human reasoning And revelation which concurs with it, The highest of thy loves to God doth span. But are there other cords which pull thee tight To him? Show

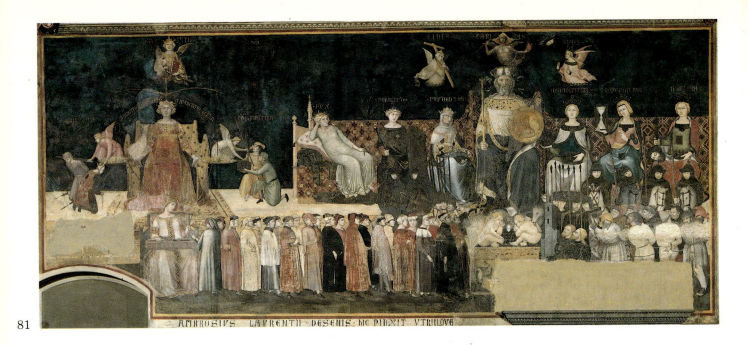

by thy words how many are The teeth whereby this love of thine doth bite). In this fresco, right in the midst of the city bustle, there is a group of nine young girls dancing in a circle to a rhythm kept by a tenth girl playing a tambourine; this stresses once again, visually this time, the harmony and concord that reign in the city. And all the inscriptions in the painting are also references to the musical origin of the word: *laddove sta legata la Iustitia / nessun al ben comune giamay sacorda* (where Justice is fettered / no one is ever in accord with the common good), while below Tyranny the inscription reads *per adempir la sua nequitia / nullo voler ne operar discorda / dalla natura lorda / di vitii che con lei sono qui congionti* (to satisfy her iniquity no intention nor action can discord from the foul nature of the vices that are together with her here). Another important fact that explains the presence of the two ropes or cords is that in the Middle Ages a good harmony in music was not, as it is today, made of three notes (such as C-E-G), but of two sounds, as Isidor of Seville explains in his *Etymologiarum Libri* (III, 20).

Since dancing in the streets was forbidden by law in the city of Siena, and also since the young girls are much too large in proportion to the other people portrayed in the fresco, this scene is clearly intended as a symbolic representation rather than as a real event. There are many possible interpretations: the nine Muses and a reference to the Council of Nine who ruled the city, or the concord among the citizens that reigned in Siena. Let us turn to Dante once again, to the passage (*Paradise* VI, 124-126) where divine justice assigns different rewards to the souls according to their merits, without this in any way altering their harmony and concord: *Diverse voci fanno dolci note; / così diversi scanni in nostra vita / renden dolce armonia fra queste rote* (As different voices down on earth agree In one sweet music, so our difference Of rank makes in these wheels sweet harmony).

The procession of the twenty-four citizens, all dressed in rich and elegant clothes, is obviously a collection of the most influential members of Sienese society, bankers, rich merchants, learned scholars (but there is also a knight among them). It is possible that the Council of Nine, instead of having themselves portrayed, asked Lorenzetti to portray the government of the twenty-four, which had ruled Siena from 1236 to 1270, opposing the absolute power of the Podestà and the great families; they had formed the council which was called the "Elected Consistory" and had marked the entrance of the *populus* in the government of the Commune. In a propaganda instrument, like this fresco, a reference to the past was intended probably to provide the reassurance of tradition and history and to suggest, precisely because of the experience of the past, the existence of a greater opening to the lower classes, much more than was actually the practice of the Council of Nine, although they undoubtedly were inspired by the 13th-century example.

At the time this fresco was painted, the government of the Council of Nine had been threatened several times by conspiracies organized by the aristocracy (countered by laws prohibiting certain noble families from holding positions in the magistratures) and by revolts of the working classes. These insurrections, however, made the Council of Nine promise that they would form a council also of "good men" from the populace, to work alongside the Nine, who were primarily bankers and powerful merchants. This was dictated by the fear of rising discontent; in 1337, for example, the statutes of Siena were amended with a promise to increase the number of citizens eligible to hold positions in the supreme magistrature, and other similar amendments were passed in 1339 as well.

The procession of the twenty-four offers the rope to the imposing figure of an old man, dressed like a royal judge, with a sceptre, shield and crown. He is the Commune of Siena, and his black and white garments

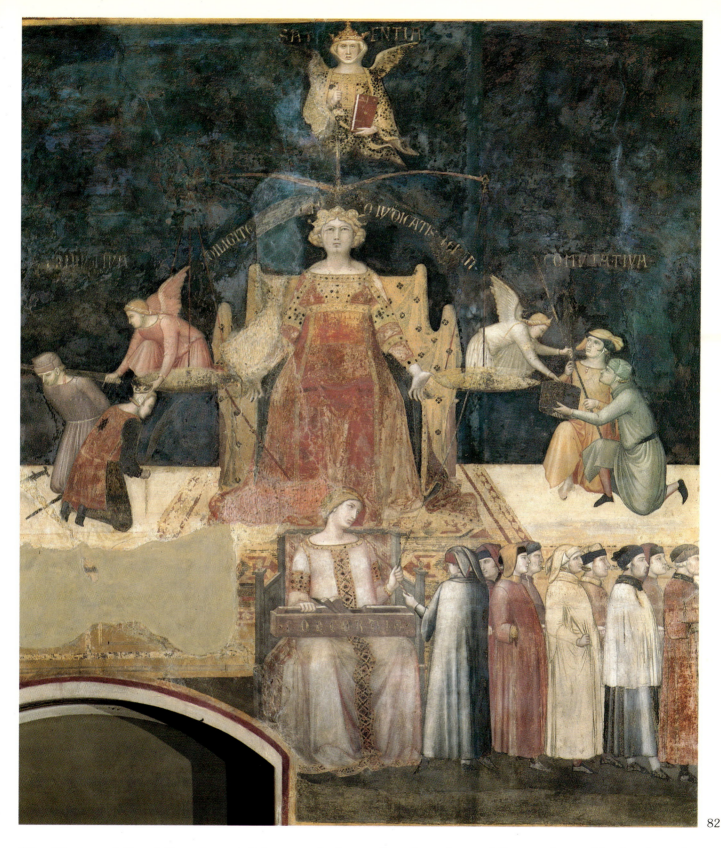

81. *Allegory of Good Government (photographed during restoration)*
Siena, Palazzo Pubblico

82. *Allegory of Good Government (photographed during restoration), detail showing Justice*
Siena, Palazzo Pubblico

reflect the colours of the city. Around his head are the letters CSCV (a further C is the result of a recent restoration), meaning *Commune Senarum Civitas Virginis*. He is the "Bene Comune" or "Common Good" in all the ambiguity of the Italian term, both the "Good of the Commune" and the "Good of the Community", that is of all its citizens. The inscription along the border of the fresco further explains the concept: *Questa*

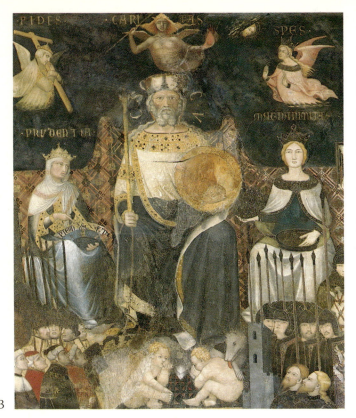

83

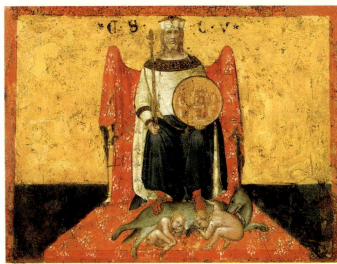

84

83. *Allegory of Good Government (photographed during restoration), detail*
Siena, Palazzo Pubblico

84. *The Good Government painted on the cover*
of a "Biccherna" ledger
Siena, States Archives

santa virtù ladove regge / induce adunita li animi molti. Equesti accio riccolti / un Ben Comun perlor signor sifanno (This holy virtue—Justice—where she rules leads many spirits to unity. And they, gathered together, make a Common Good for God). On the shield there is a depiction of the Madonna and Child, the protectress of Siena after the battle of Montaperti. At the feet of Good Government are the twins Senius and Ascanius and the she-wolf, symbolizing the ancient and noble Roman origins of the city. Above the head of the old man are the three Theological Virtues, Faith, Hope and Charity; the first bears a cross, the second turns her eyes towards Christ and the third, above the others, carries a heart and an arrow symbolizing not only *amor Dei et proximi* (as in the Massa Marittima altarpiece), but also *amor patriae* according to the definition of Tolomeo da Lucca: "the love of one's fatherland has its roots and foundations in charity." This Virtue is placed here in the highest position for it is the one that considers the good of the community most important. Just as Justice is an emanation of Divine Wisdom, in the same way its practical application in the reality of the Common Good is also connected to God, for it is inspired by the highest principles. On the same dais as the throne of the Common Good are seated the Cardinal Virtues, Fortitude, Prudence, Justice and Temperance; Lorenzetti has added Magnanimity and Peace to the traditional four.

The extremely famous figure of Peace, all dressed in white, reclines on a couch resting on a mound of weapons; she is set apart from the other Virtues, to emphasize the importance of her presence. Around her head is a garland of olive and she holds another olive branch in her hand. Her iconography is based on

Roman coins depicting *Securitas*, who is also portrayed, with a little model of a hanged man in her hand, just outside the city gates, painted according to the classical iconography of Victory. *Securitas* and *Pax* are the two foundations of concord: in the city, security lies in the peace of its inhabitants, for there are no enemies; from the distant horizons there might be a danger of attacks, but all roads are victoriously peaceful. On the scroll held by *Securitas* it says: *Senza paura ognuuom franco camini / e lavorando semini ciascuno / mentre che tal comuno / manterrà questa donna in signoria/ chel alevata a rei ogni balia* (Without fear every man shall walk freely / and each, working, shall sow / while this commune / shall keep this woman (*Securitas*) in power / for she has removed all power from the wicked). Next to Peace sits Fortitude, armed with a mace and a shield, indicating firmness, the same firmness that the soldiers at her feet, some on horseback and some on foot but carrying long sticks, are doubtless ready to demonstrate. In the same way, at the feet of Justice and the others to the right of the old man, there is a crowd of armed soldiers, watching over a group of prisoners. This is an armed, military peace, achieved by the defeat and conquest of the enemy, frequently only after his physical destruction. In the Middle Ages, as we said earlier, the olive branch was a symbol of peace or of a truce, but only after the defeat of the enemy. Villani, for example, says that the Florentines, to celebrate one of

85. *Allegory of Good Government (photographed during restoration), detail*
Siena, Palazzo Pubblico

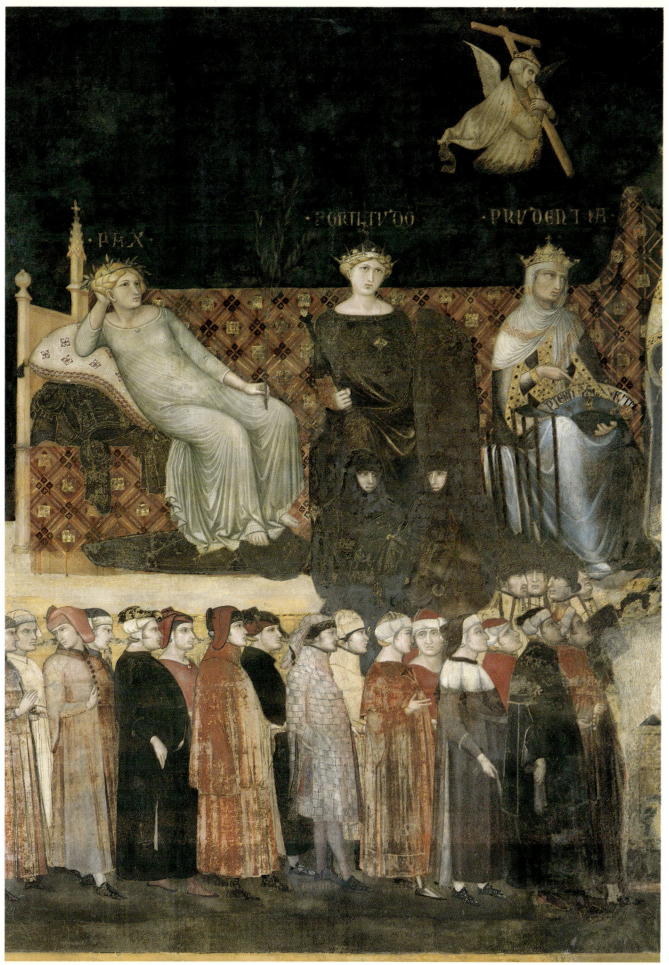

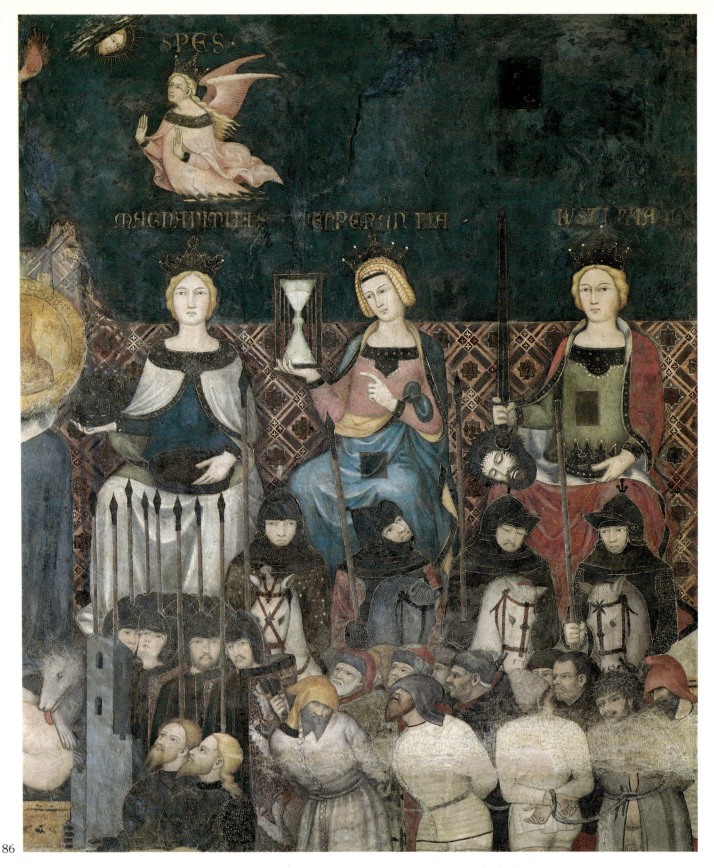

86. *Allegory of Good Government (photographed during restoration) detail showing Magnanimity, Temperance, and Justice*
Siena, Palazzo Pubblico

87. *Effects of Good Government in the City, detail*
Siena, Palazzo Pubblico

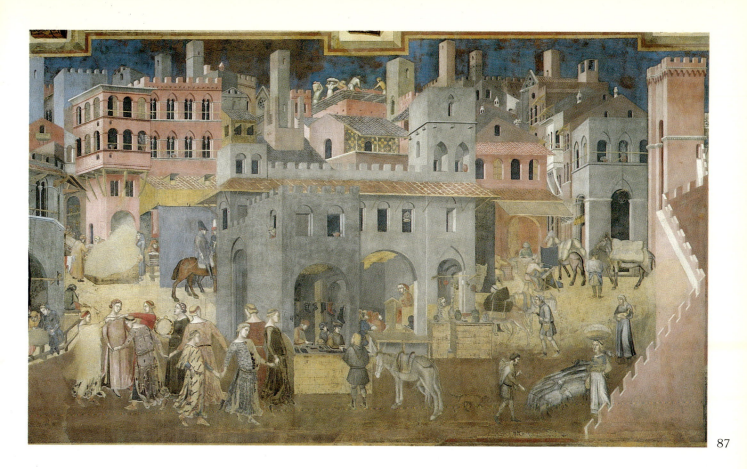

their victories against the Sienese in 1260, had a tower built on a hilltop that could be seen from Siena, "and to humiliate the Sienese and commemorate the victory, they filled it with earth and planted an olive tree inside it, which was still there in our times." Next to Peace, calmly resting but well-guarded by weapons, and Fortitude, comes Prudence, an elderly queen holding a shield with the inscription *praeterita*, *praesencia*, *futura*, a recommendation to govern with wisdom and only after having taken all things into consideration.

The next Virtue is Magnanimity, with a tray overflowing with coins, followed by Temperance with an hour-glass (from the incorrect etymology: *tempus*); this attribute replaces the traditional two *ewers* of water being poured from one to the other, where the etymology was obviously derived from *temperare*. Clearly, with the growing importance of urban life, time was considered more precious, since it was also seen as a source of income. The last Virtue is Justice, holding a severed head in her lap and a sword in her hand, threateningly; one' of the armed soldiers on horseback watching over a group of prisoners looks up at her. To conquer one's enemies, not to be crushed by defeat, to pardon those who surrender: these are the soldier's virtues. And, in fact, also in this part of the fresco there are two kneeling men offering up their castles, while nearby is a group of fettered peasants, obviously the symbol of a crushed revolt. On this side of the Common Good we see the Virtues of civic power, which help to govern in peace and wisdom, but always with firmness.

The city of Siena, bathed in the light of justice and 87 divine wisdom, appears joyful and sunny. Men go about their work with calm, almost without effort, and there is even time for happiness. To the left, in fact, we see a wedding procession, with the bride being led 88 to the ceremony; then we see a tailor, with his back to us, sewing, and a little further away, a goldsmith's workshop, a merchant examining his ledgers, and some noblemen on horseback. To the right, in the foreground, a cobbler's workshop (there is even a little child peeking out), a teacher with his pupils, a shop selling wines and meats, where a peasant with a basket of eggs on his arm and his donkeys laden with wood is headed. A shepherd with his flock is leaving the city for the countryside, while a peasant with his mules carrying bales of wool is arriving; he is taking the wool to a nearby shop, where a group of men and women are busy weaving and examining fabrics. There are also two peasant women arriving from the country with all sorts of provisions and hens. The city walls are like an architectural stage-set, placed there to stress this constant to and froing of people and animals; the gates are open, indicating that there is no fear of enemies. Already fairly well out into the countryside there is a merry party of gentlemen on horse- 91 back, setting off on a hunting expedition, stopped for a minute by a blindman begging. A peasant, coming from the other direction, is leading a piglet to market in the city, and other peasants, alone or in groups (there is even a whole family), are moving along the roads leading to and from the city. In the city, the buildings are very beautiful, and quite recognizably

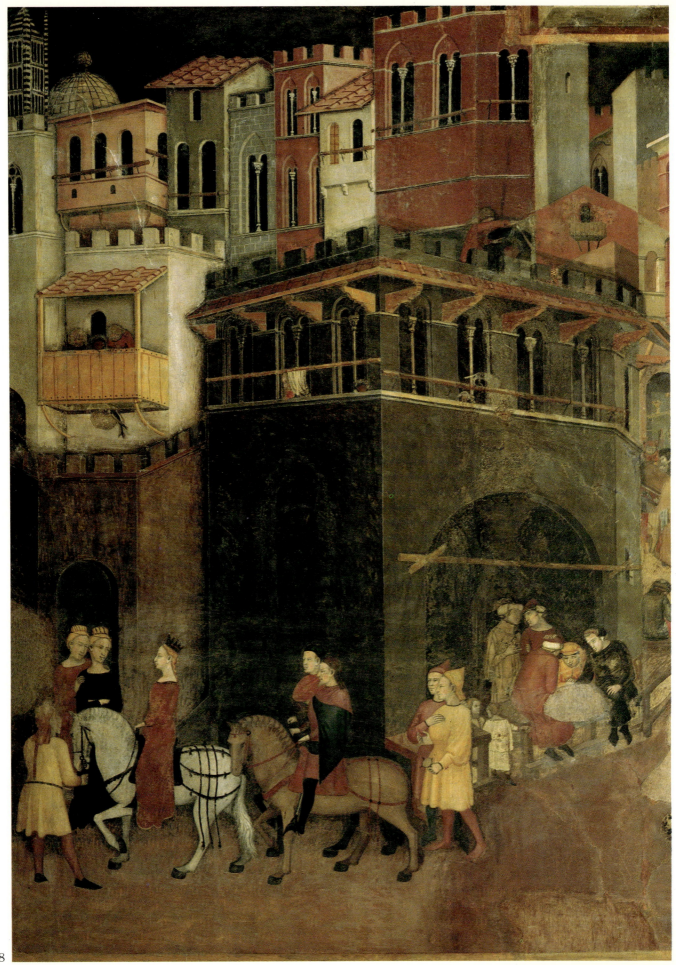

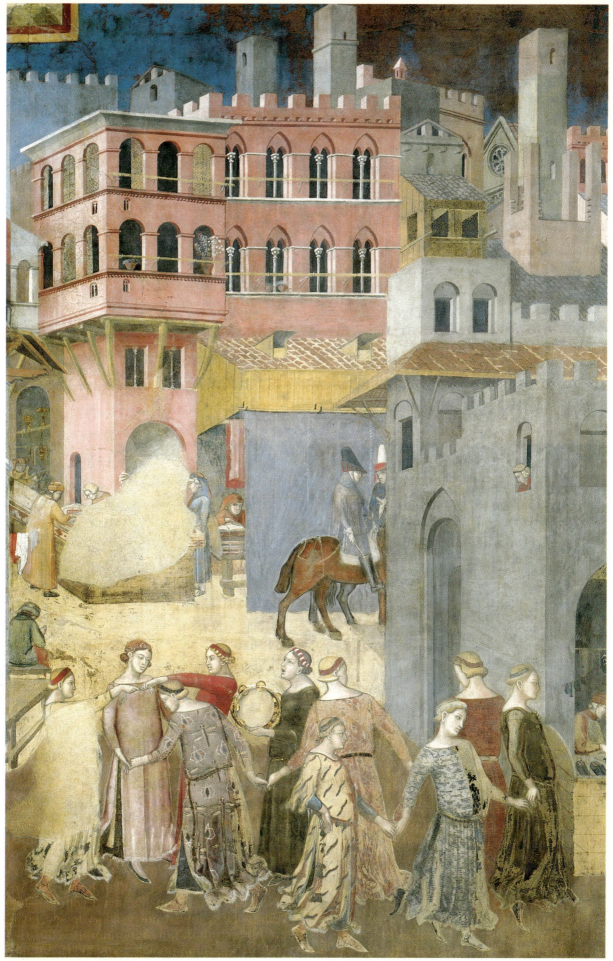

89

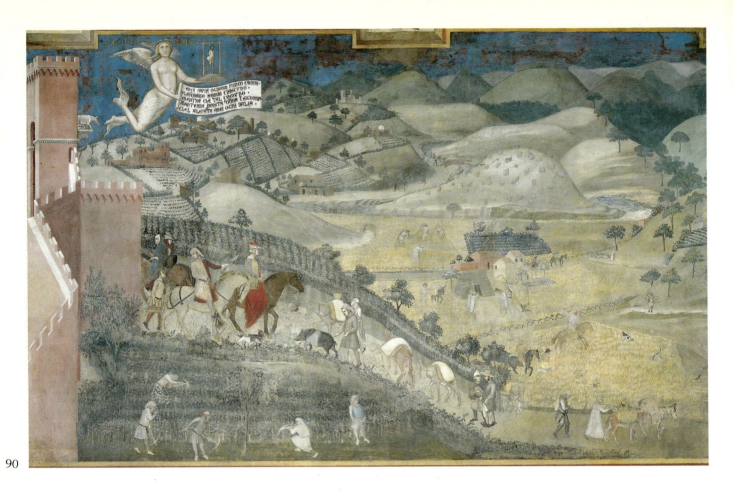

90

Sienese, even though it is impossible to establish exactly what part of the town Lorenzetti has portrayed. Precisely because the fresco is in a sense the political manifesto of the Council of Nine, and their architectural achievements were what they were proudest of, the view of the city is to be seen as a realistic, but not a real, depiction, clearly identifiable as Siena. On the
87 rooftops there are masons at work, and there is even a woman among them. In this exaltation of manual labour, practical activities and crafts (formalized in the Mechanical Arts), together with the Liberal Arts, Lorenzetti was emphasizing a new social reality: in the city all professions are mutually "useful and necessary," as long as no one attempts to change his status, setting in motion dangerous revolts. The social order is imposed by God and as such it must be respected: "Why has God created so much difference in the world, the rich, the poor, the strong, the weak? And yet he cares for them all; for if everyone was king, who would bake bread, who would till the soil?" as Giordano da Pisa, an early 14th-century Dominican preacher, puts it. Therefore, although the fresco is a manifesto of political propaganda, the empty orbs of the blindman can co-exist with the gentleman's entertainment, and the hunting party's horses sweeping across the wheat fields and vineyards of the beautiful Sienese countryside can be tolerated by the peasants hard at work tilling the fields.

It has been pointed out that this depiction of the countryside is not realistic, for Lorenzetti has shown the produce of both winter and summer, and peasants are sowing, ploughing and harvesting wheat while the vineyards are still green. But the artist has scattered peasants at work throughout his vast landscape with 90 the subject of the Months of the Year in mind, and he has included even the storing of wood for the winter, and of meat (the piglet being led to the city); and he has not forgotten olive oil, with the lovely olive tree just outside the city walls. He has also painted wide expanses of golden wheat fields, a rather reassuring answer to the revolts that were so frequently breaking out in the early 14th century because of food shortages. Amidst the hills and through the plains, everywhere there are rivers and streams, occasionally opening up into small lakes; in the distance the dark patch of the sea, with the harbour of Talamone, Siena's commercial port. All these sources of water are part of the propaganda message of the fresco as well, for we know that Siena was constantly searching for new water supply sources. These elements taken from reality, in some cases quite a distant reality, but all gathered together in this fresco give us an imaginary landscape which, in the mosaic-like juxtaposition of concrete details, is unmistakably the Sienese countryside. The roads that divide the countryside into regular patterns are also based on reality, for they are wide, just as the magistrates in charge of road construction and maintenance ordered them to be. The road that leads to the city is actually paved with flagstones and bordered by a low stone wall. A lovely brick three- 92 span bridge (and not a temporary construction in wood), with an impressive caravan crossing it, stands

88. *Effects of Good Government in the City, detail (photographed during restoration)*
Siena, Palazzo Pubblico

89. *Effects of Good Government in the City, detail*
Siena, Palazzo Pubblico

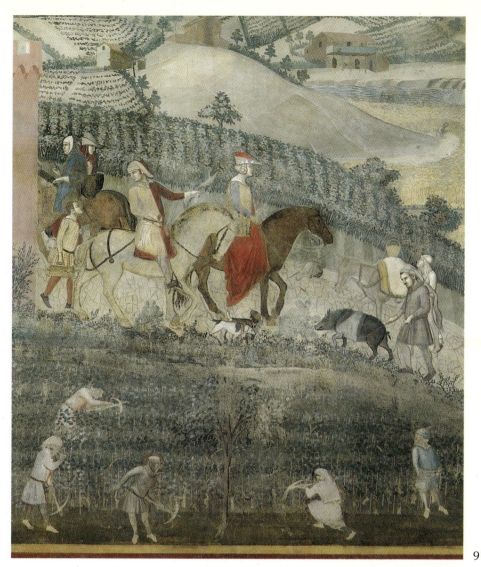

91

90-92. *Effects of Good Government in the Countryside, detail*
Siena, Palazzo Pubblico

92

in the foreground, and there are several other bridges in the background. The donkeys are laden with bales of wool bearing the same mark as those already being unloaded at the weaver's workshop. Documents of the period stress the fact that roads had to be in good condition in all weather, even in winter, therefore not interrupted by mud or landslides; and also safe from brigands and enemies. Furthermore, roads had become indispensable for the survival of the city: the population crowded inside the restricted area within the walls felt that the good condition of the roads was essential to their very survival. The pride of these fully efficient roads that purvey riches, always kept in perfect condition and free from dangers, is emphasized by the words and the attribute of *Securitas: senza paura ognuuom franco camini* (without fear every man shall walk freely). On the contrary, *Timor* proclaims: *per questa via non passa alcun senza dubbio di morte / che fuor si robba e dentro dele porte* (along this road no man shall pass without risking his life, for there is stealing outside and within the gates). The nobles, the merchants and the bankers all had large properties in the countryside, and they represented, in the eyes of the contemporary observer, just like the splendid palaces in the city, the symbol of extraordinary economic wealth. It is not by chance that in the countryside near Siena the only buildings we see are scattered houses next to vegetable gardens, huts, and other constructions with no defence structures at all, whereas castles, fortifications and towers are all placed very far away, in the background or along the edges of the hills, indicating a need for defence that the settlements near the city do not have: the peace and security that reigns within the walls is extended to the immediate surroundings.

The interest that Ambrogio shows in the depiction of Siena's daily life, his rediscovery of landscape and nature in its most varied aspects, is something totally new, which breaks away from a consolidated tradition; and the painters of the generation immediately following his were quick to notice the fact. For example, Giovanni di Paolo (1400-1482) in his Flight into Egypt, which was almost certainly originally part of a polyptych painted in 1436 (in the Siena Pinacoteca), literally copies whole scenes from this fresco: the ploughing, the winnowing, the peasants' hut, the mill and the village in the distance; even his Holy Family and the two holy women accompanying them are modelled on the two peasants and the family on horseback that Lorenzetti painted on their way into the city (and, further, Giovanni painted a city full of crenellations, very similar to the little painting of the City by the Sea: this can be used as yet another element in favour of its attribution to Ambrogio).

In this part of the painting as well the subject is didactic and political, but placed in the observer's natural environment. We can say that it is the daily practicalities of city life, the interest for all things that concern man, that is responsible for this innovation in Ambrogio's allegorical language. It is in this light that we must also see the extremely large part of the painting devoted to the countryside and peasant activities, which in earlier paintings had been restricted almost exclusively to illustrations of Adam's curse in the Bible. With the development of the city, of a differentiated and specialized kind of manual labour, the values change, and each form of activity is judged according to its usefulness to society; so, even the peasant is seen as contributing to economic progress. And, in any case, the constantly growing population of the city needs more and more food from the country. The realistic portrayal of nature and of the life in the city and its inhabitants, with the simple language of familiar scenes, contributes to making the whole even more convincing, as though this was a faithful depiction of reality, the reality that probably only existed in the political propaganda of the Council of Nine.

Bibliography

Pietro Lorenzetti

The relevant material up to 1961 may be found under LO-RENZETTI, Pietro e Ambrogio, ed. by L. BECHERUCCI in ENCICLOPEDIA UNIVERSALE DELL'ARTE, Venezia, Cini, 1977 vol. VIII, cols. 688-700. Note that of the vast bibliography relating to Pietro we shall consider above all those works cited in the present publication; the works are listed in alphabetical order:

C. BRANDI, *Pietro Lorenzetti*, Rome, Edizioni Mediterranee, 1958

J. BRINK, *A secret Signature on Pietro Lorenzetti's 'Pieve Altarpiece'*, in 'Commentari', 28, 1-3, 1977, pp. 137-8

E. CARLI, *La pittura senese del Trecento*, Milan, Electa, 1981

J. A. CROWE, G. B. CAVALCASELLE, *A New History of Painting in Italy*, London, 1964, vol. II

G. ERCOLI, *L'antica pittura senese e il Vasari* in 'Bullettino senese di Storia patria', 84-85, 1977-78, pp. 93-113

M. S. FRINTA, *Deletions from the Oeuvre of Pietro Lorenzetti and related Works by the Master of Beata Umiltà, Mino Parcis da Siena and Jacopo di Mino del Pellicciaio* in 'Mitteilungen des Kunsthistorischen Institutes in Florenz', 20, 3, 1976, pp. 271-300

C. GARDNER von TEUFFEL, *The Buttressed Altarpiece: a forgotten Aspect of Tuscan XIV Altarpiece Design* in 'Jahrbuch der Berliner Museen' 21, 1979, pp. 21-65

R. KOCH, *Elijsah the Prophet, Founder of the Carmelitan Order*, in 'Speculum', 34, 1959, pp. 547-560

H. B. J. MAGINNIS, *Pietro Lorenzetti's Carmelite Madonna: a Reconstruction* in 'Pantheon', 33, 1, 1975, pp. 10-16

H. B. J. MAGINNIS, *Assisi Revisited: Notes on Recent Observations*, in 'Burlington Magazine' 117, August 1975, pp. 511-517

H. B. J. MAGINNIS, *The so-called Dijon Master* in 'Zeitschrift für Kunstgeschichte', 43, 2, 1980, pp. 121-138

H. B. J. MAGINNIS, *Pietro Lorenzetti: a Chronology*, in 'Art Bulletin', 66, 2, 1984, pp. 183-211

S. NESSI, *La Basilica di S. Francesco in Assisi e la sua documentazione storica*, Assisi, Casa Editrice Francescana, 1982

C. F. O'MEARA, *In the Hearth of the Virginal Womb: the Iconography of the Holocaust in Last medieval Art* in 'Art Bulletin' 63, 1, March 1981, pp. 75-88

E. PANOFSKY, *Rinascimento e rinascenze*, Milan, Feltrinelli, 1971

M. SEIDEL, *Gli affreschi di Ambrogio Lorenzetti nel chiostro di S. Francesco a Siena* in 'Prospettiva', 18 (July) 1979, pp. 10-19

G. SINIBALDI, *I Lorenzetti*, Siena, Istituto Comunale d'Arte e Storia, 1933

I. UGURGIERI, *Le pompe senesi*, Pistoia, 1649

F. ZERI, *Pietro Lorenzetti, quattro pannelli dalla pala del 1329 al Carmine* in 'Arte Illustrata', 7, 58, July 1974, pp. 146-156

Ambrogio Lorenzetti

In addition to the works already cited in the bibliography of Pietro Lorenzetti which refer to both brothers, see:

E. BORSOOK, *Ambrogio Lorenzetti*, Florence, Sadea Sansoni, 1966

E. BORSOOK, *Gli affreschi di Ambrogio Lorenzetti a Montesiepi*, Florence, Edam, 1969

D. e P. DIEMER, *Turbata est in sermone eius. . .* Tübingen, M. Niemeyer Verlag, 1979

M. D. EDWARDS, *Ambrogio Lorenzetti and Classical Painting* in *Florilegium* 2 (1980), pp. 146-160

A. EÖRSI, *Dancing Women in the Ambrogio Lorenzetti's Fresco* in 'Acta Historiae Artium', 24, 1978, pp. 85-95

K. M. FREDERICK, *A Program of Altarpiece for the Siena Cathedral* in *Rutgers Art*, 1983, pp. 18-35

R. FREYAN, *The Evolution of the Caritas Figure in the 13 and 14 Centuries* in 'Journal of the Warburg and Courtauld Institute', 11, 1948, pp. 68-86

C. FRUGONI, *Una lontana città, sentimenti ed immagini nel medioevo*, Torino, Einaudi, 1983

C. FRUGONI, *L'iconografia del matrimonio e della coppia nel Medioevo*, in *Il matrimonio nella società altomedioevale*, Spoleto 1977, pp. 901-963

D. LUCHOVIUS, *Notes on Ambrogio Lorenzetti's Allegory of Good Government* in *Rutgers Art*, 1982, pp. 29-35

A. LUCHS, *Ambrogio Lorenzetti at Montesiepi* in 'Burlington Magazine', 119/888, 1977, pp. 187-188

G. MORAN, *Studi sul Mappamondo* in 'Notizie d'arte', 10, 1982, pp. 6-7

G. MORAN, C. SEYMOUR, E. CARLI, *The Jarves St. Martin and the Beggar* in 'Yale University Art Gallery Bulletin', 31.2. 1967, pp. 28-59

A. N. MULLER, *Ambrogio Lorenzetti's Annunciation. A Re-examination* in 'Mitteilungen des Kunsthistorischen Institutes in Florenz', 21, 1, 1977, pp. 1-12

G. ROWLEY, *Ambrogio Lorenzetti*, Princeton University Press, 1958

N. RUBINSTEIN, *Political Ideas in Sienese Palazzo Pubblico* in 'Journal of the Warburg and Courtauld Institutes', 21, 1958, pp. 179-189

M. L. SCHAPIRO, *The Virtues and Vices in Ambrogio Lorenzetti's Franciscan Martyrdom* in 'Art Bulletin', 46, 1964, pp. 367-372

M. SEIDEL, *Die Fresken des Ambrogio Lorenzetti in S. Agostino* in 'Mitteilungen des Kunsthistorischen Institutes in Florenz', 22, 2, 1978, pp. 185-252

M. SEIDEL, *Gli affreschi di Ambrogio Lorenzetti nel chiostro di San Francesco a Siena, ricostruzione e datazione* in 'Prospettiva', 18 (July), 1979, pp. 10-20

E. SOUTHARD, *Ambrogio Lorenzetti's Frescoes in the Sala della Pace, a Change of Names* in 'Mitteilungen des Kunsthistorischen Institutes in Florenz', 24, 3, 1980, pp. 361-5

A. TENENTI, *Il senso della morte e l'amore della vita nel Rinascimento (Francia ed Italia)*, Torino, Einaudi, 1957

P. TORRITI, *La Pinacoteca Nazionale di Siena, i dipinti dal XII al XV secolo*, Genova, Sagep Editrice, 1977

H. Tt. van VEEN, *Lorenzo Alberti and a Passage from Ghiberti's Commentaries* in *Lorenzo Ghiberti nel suo tempo*, Florence, Olschki, 1980

V. W. WRIGHT, *The Will of Ambrogio Lorenzetti* in 'Burlington Magazine', 1975 (117), pp. 543-4

Index of the Illustrations